This Book
Belongs
To

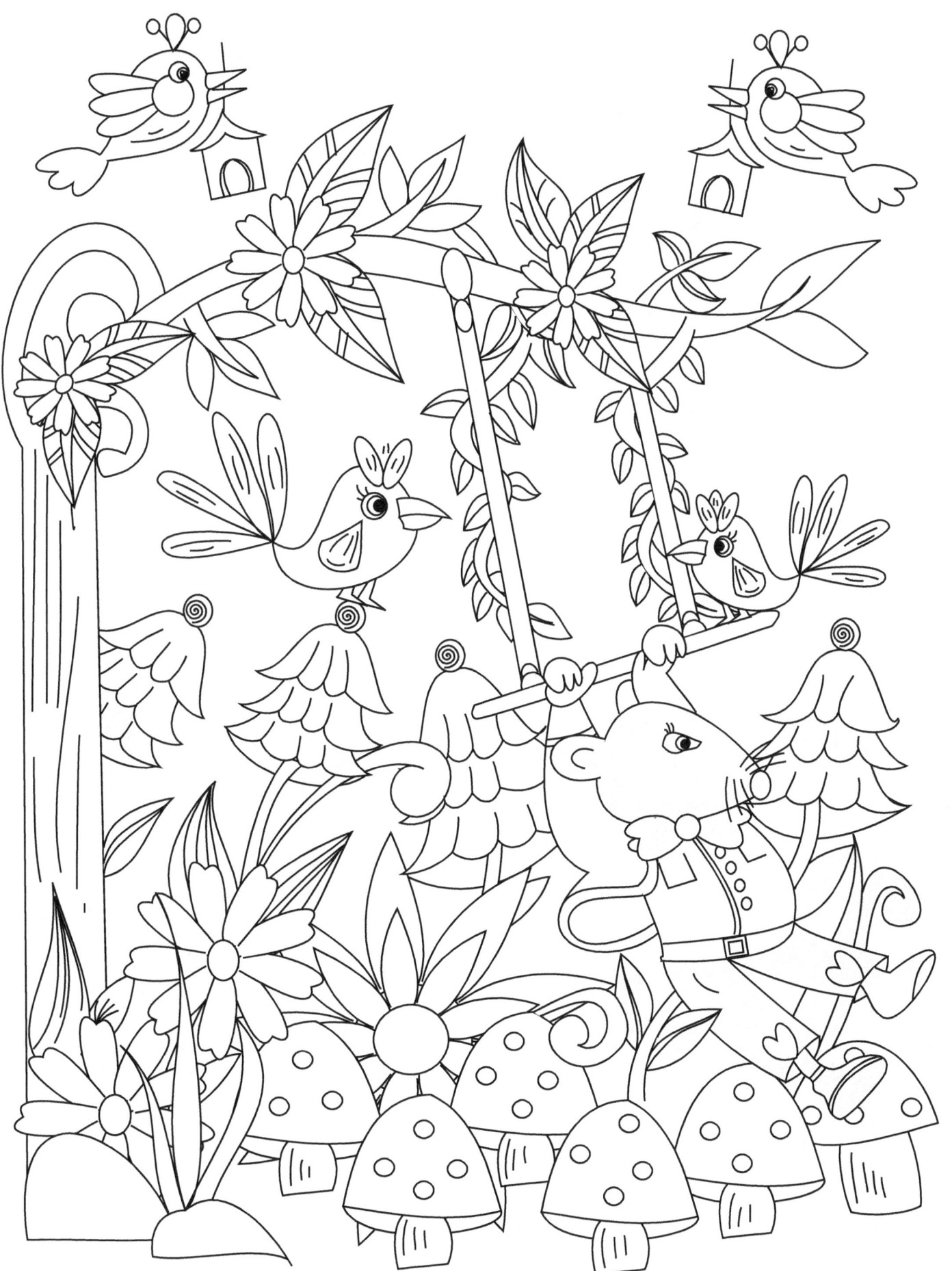

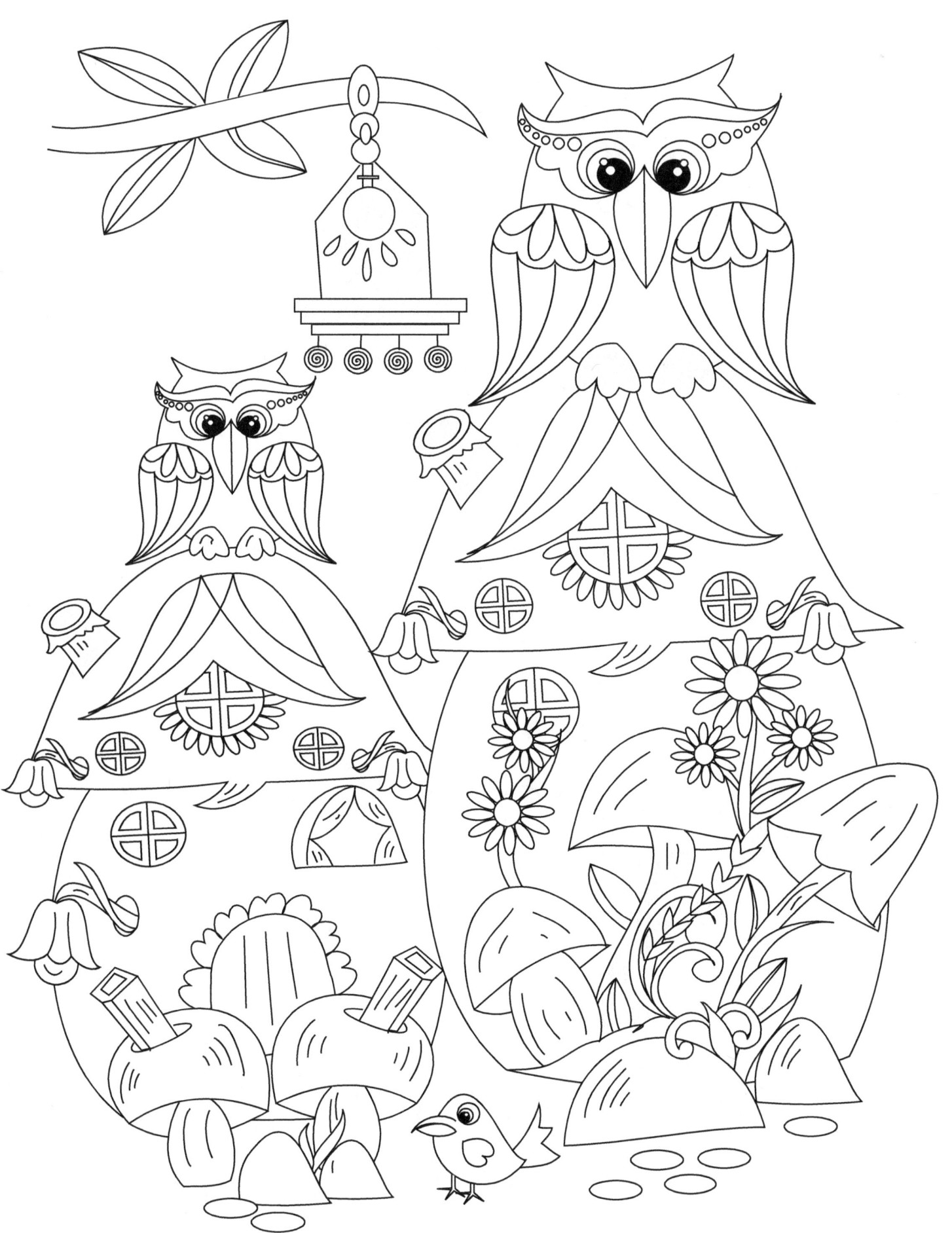

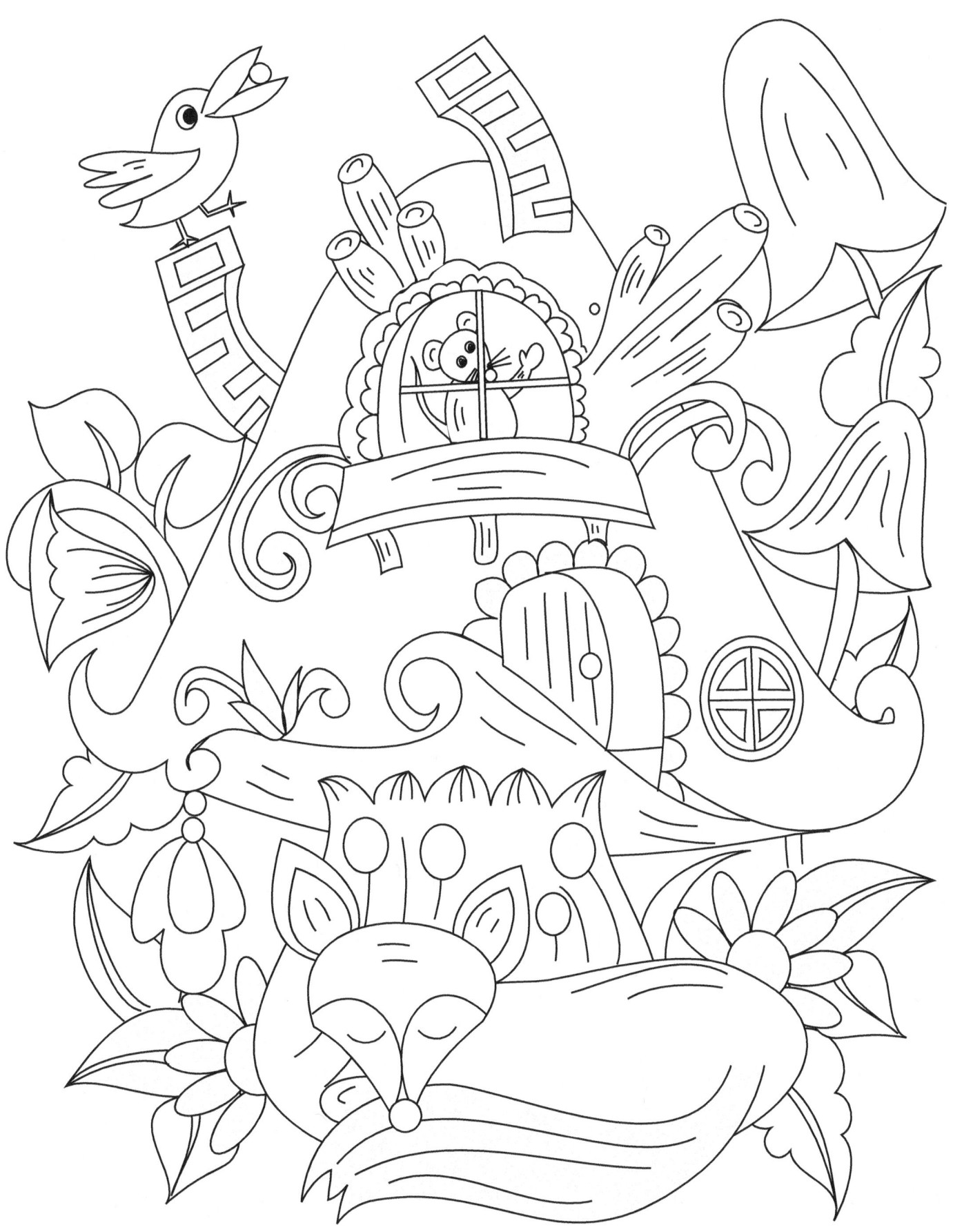

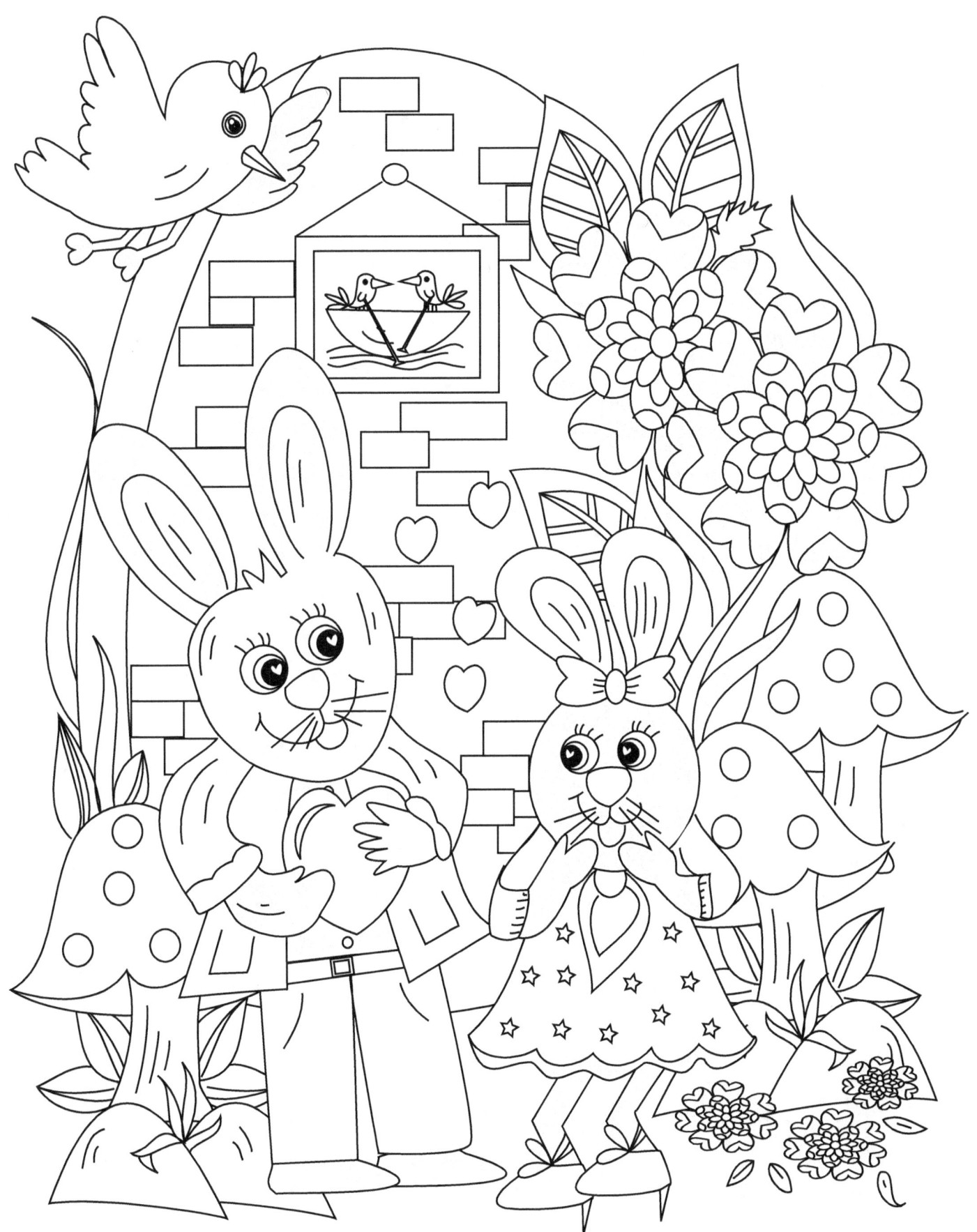

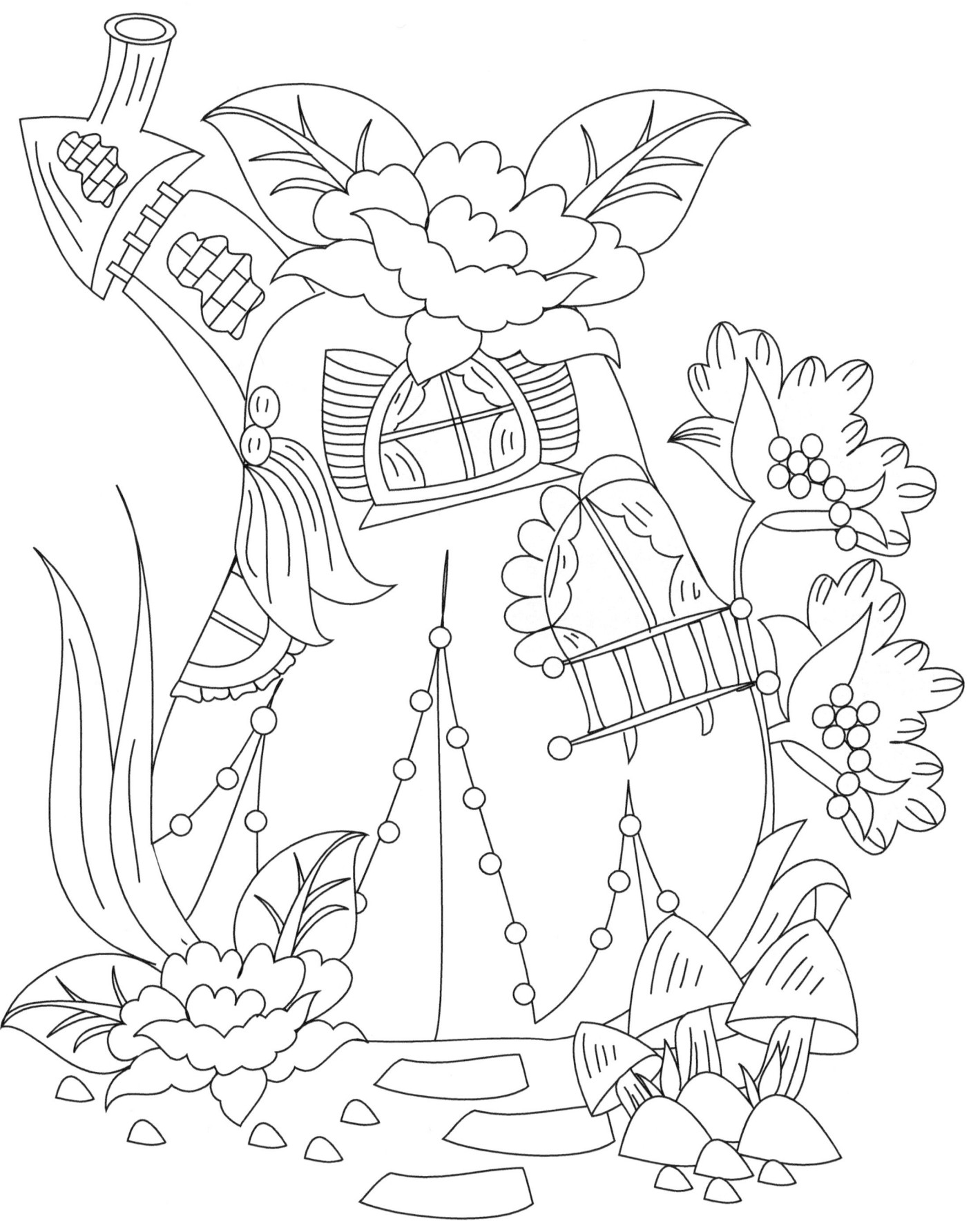

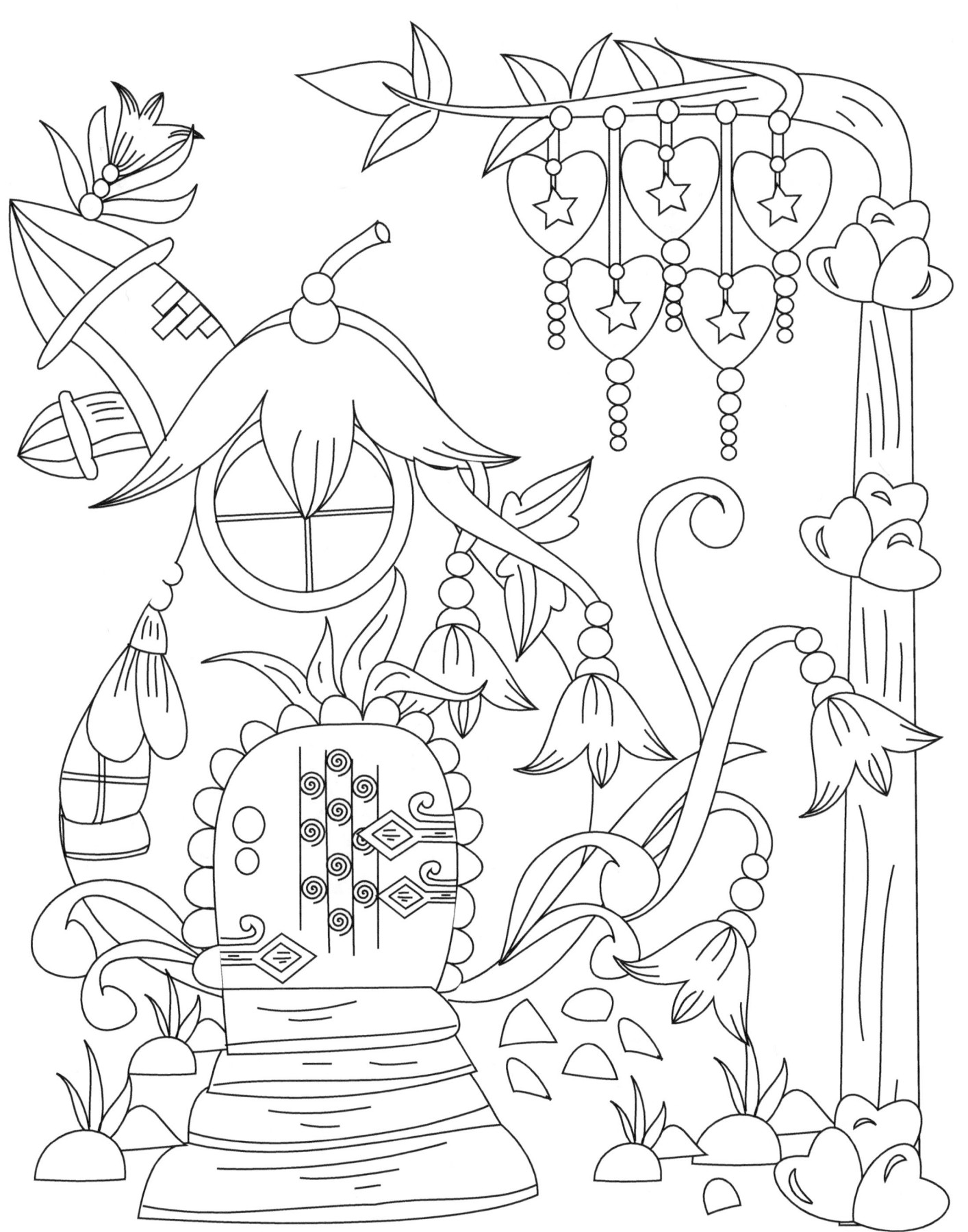

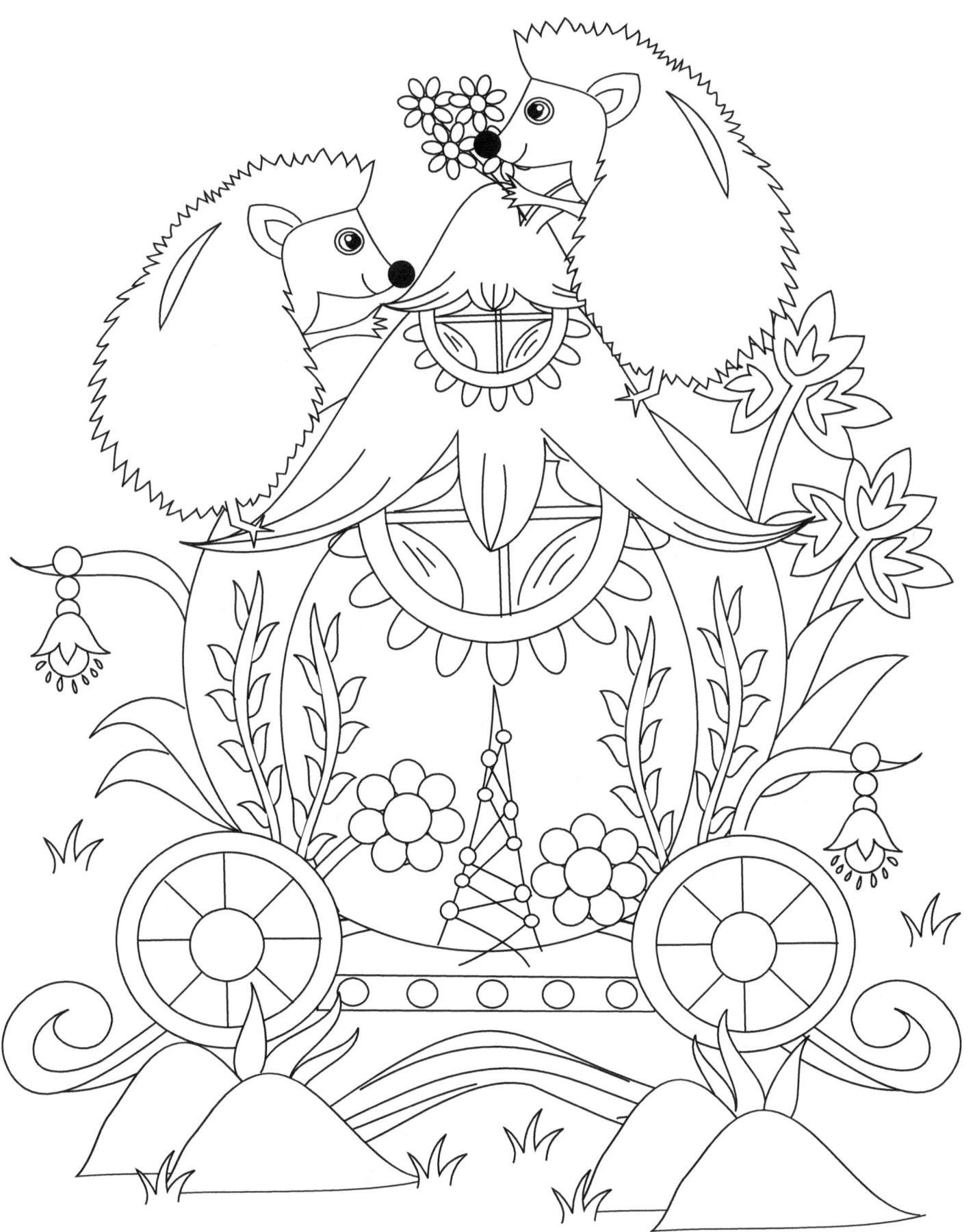

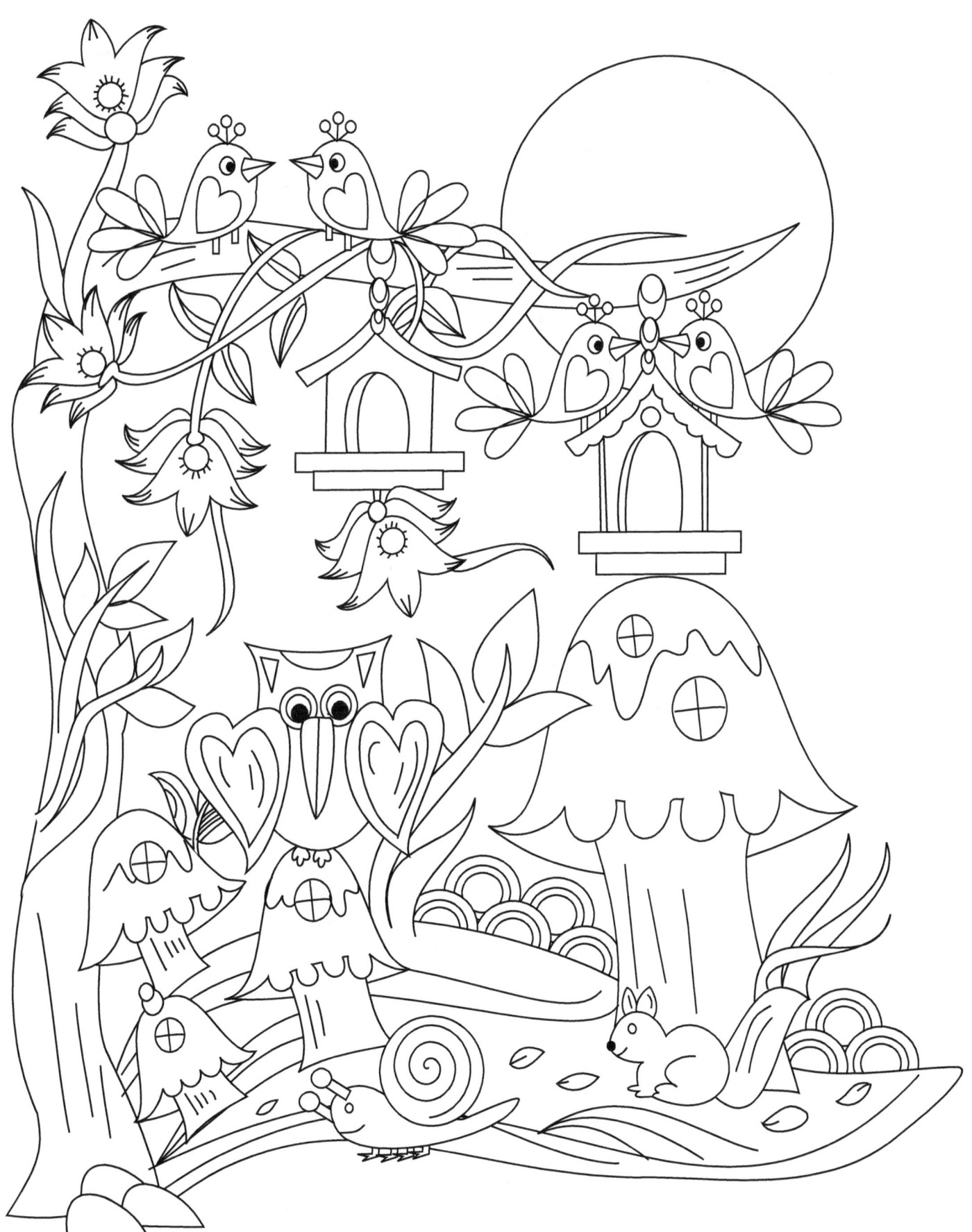

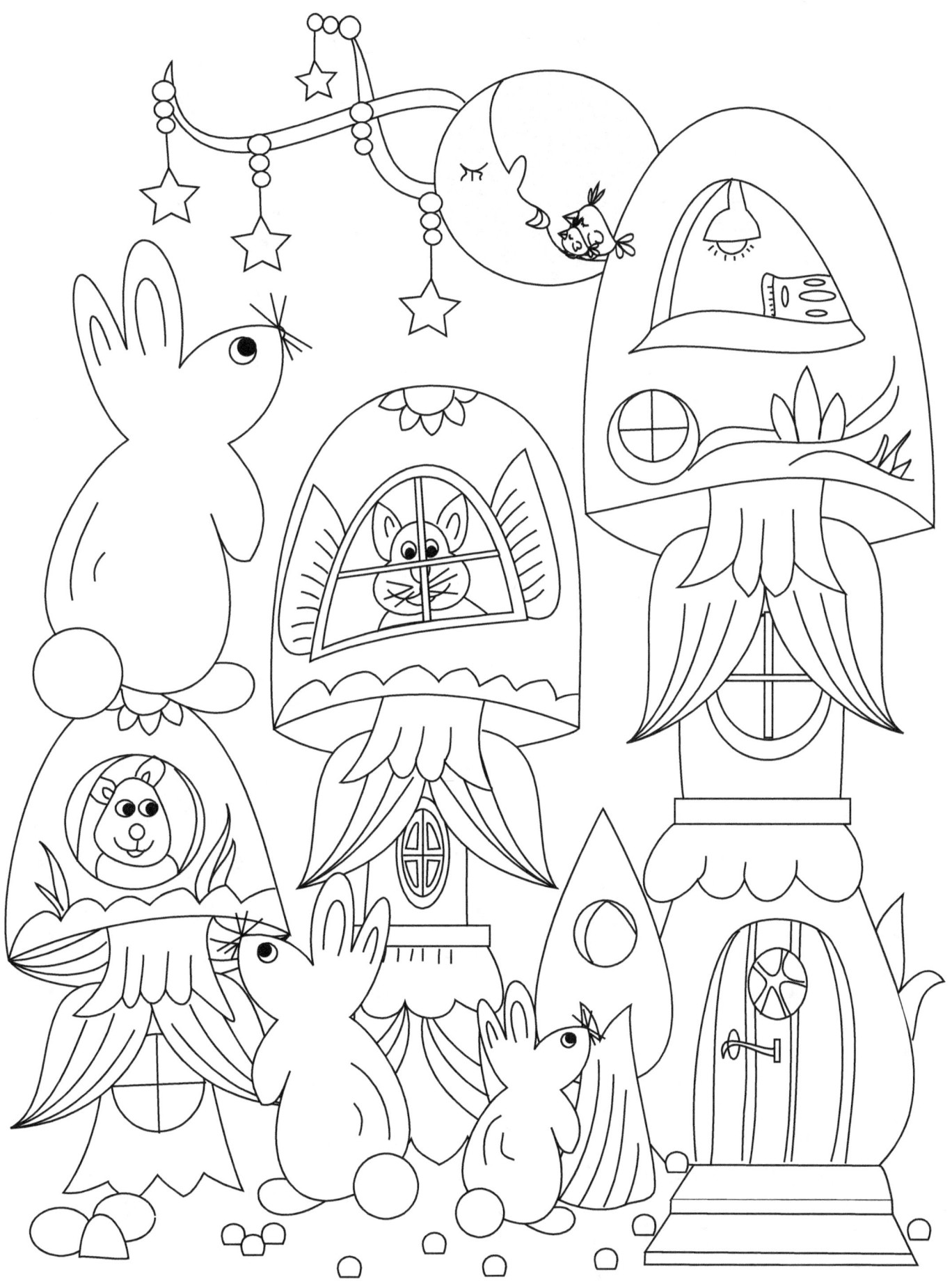

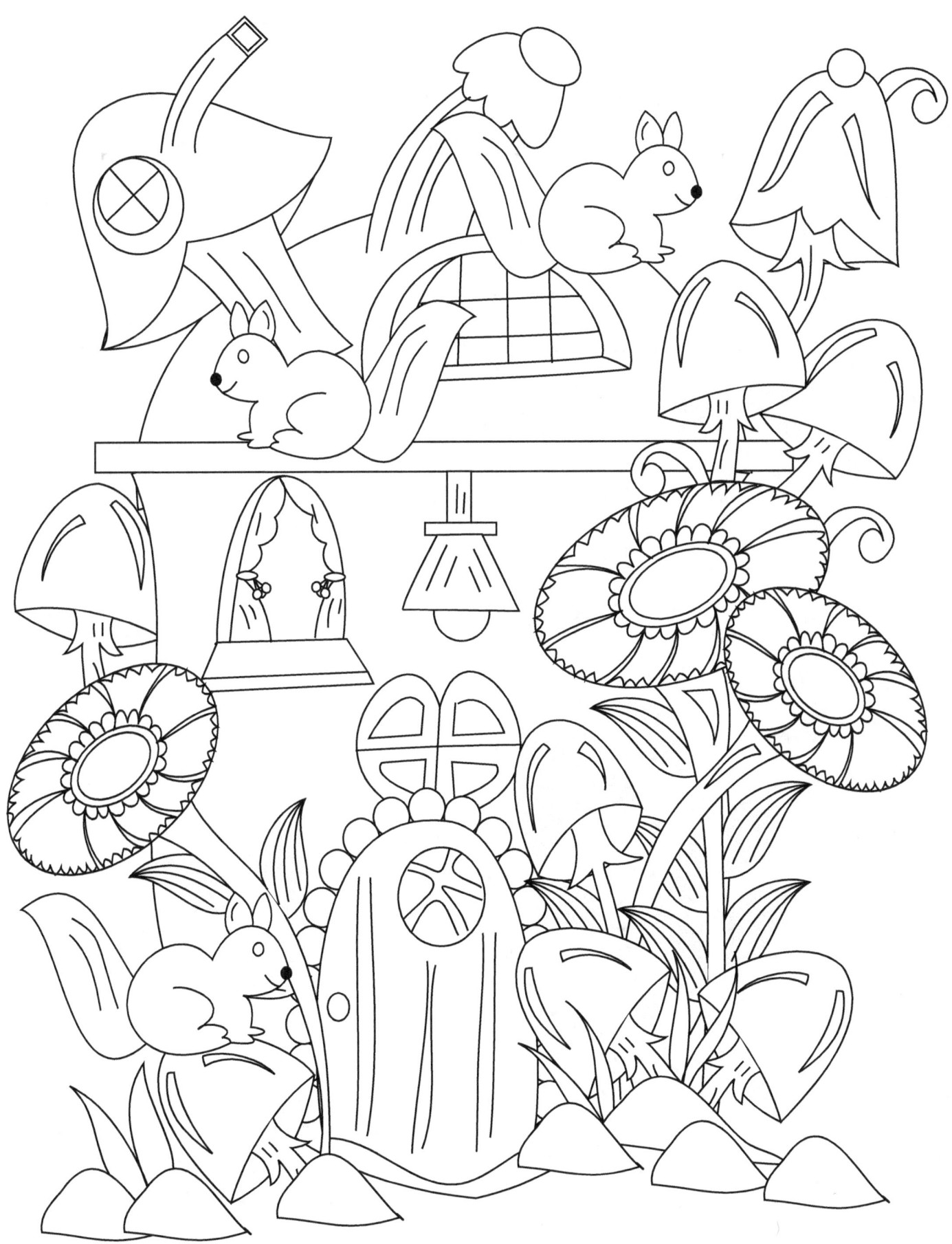

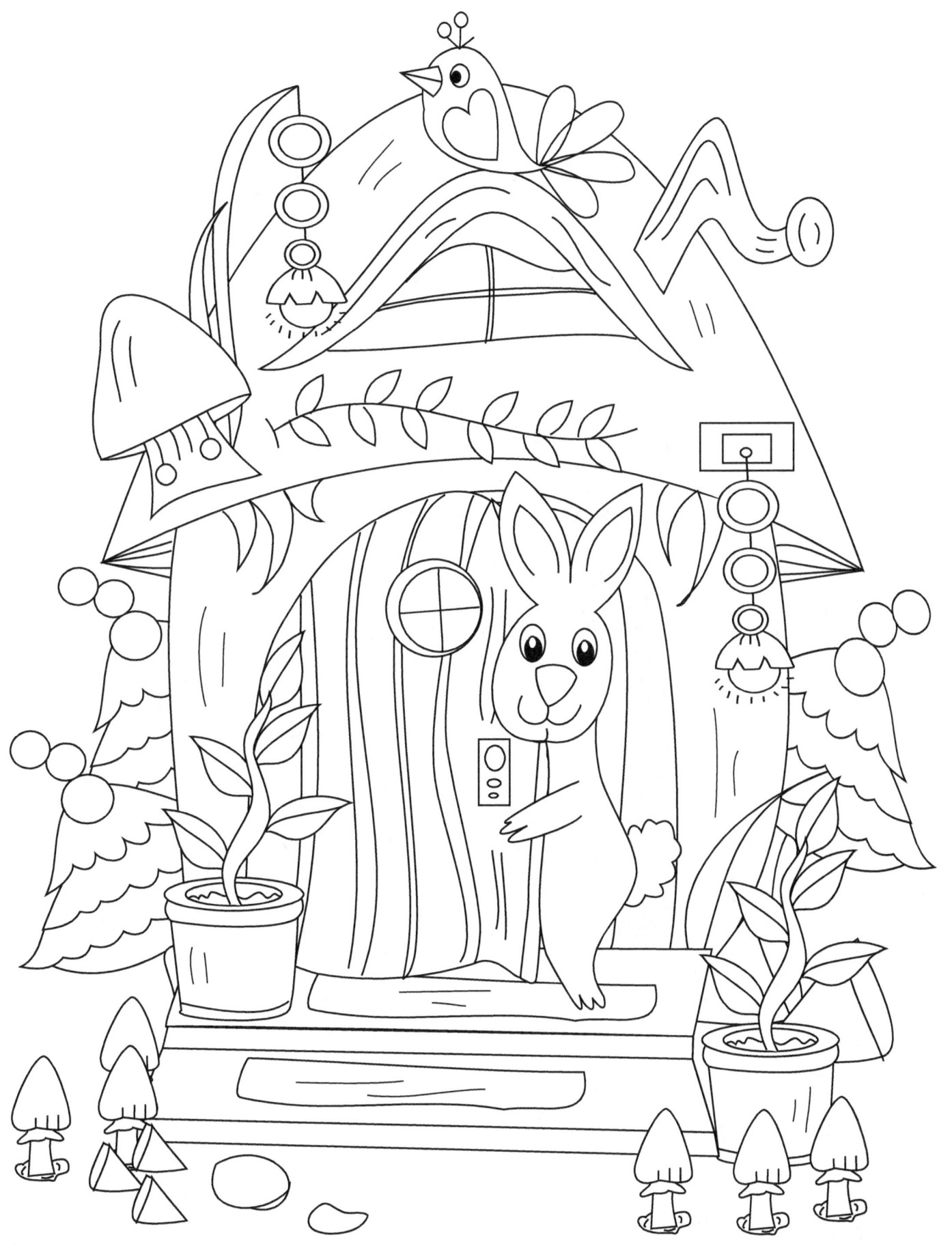

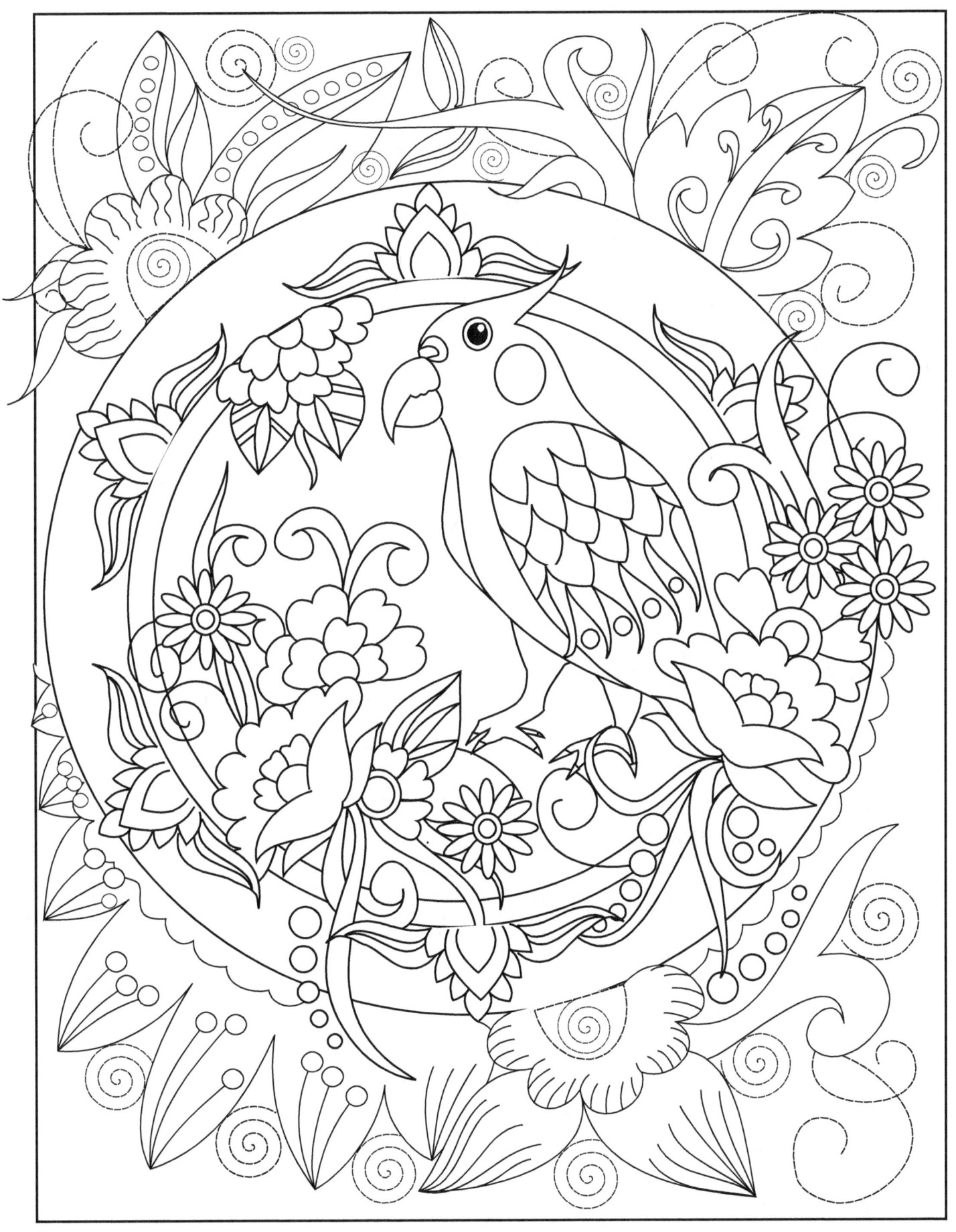

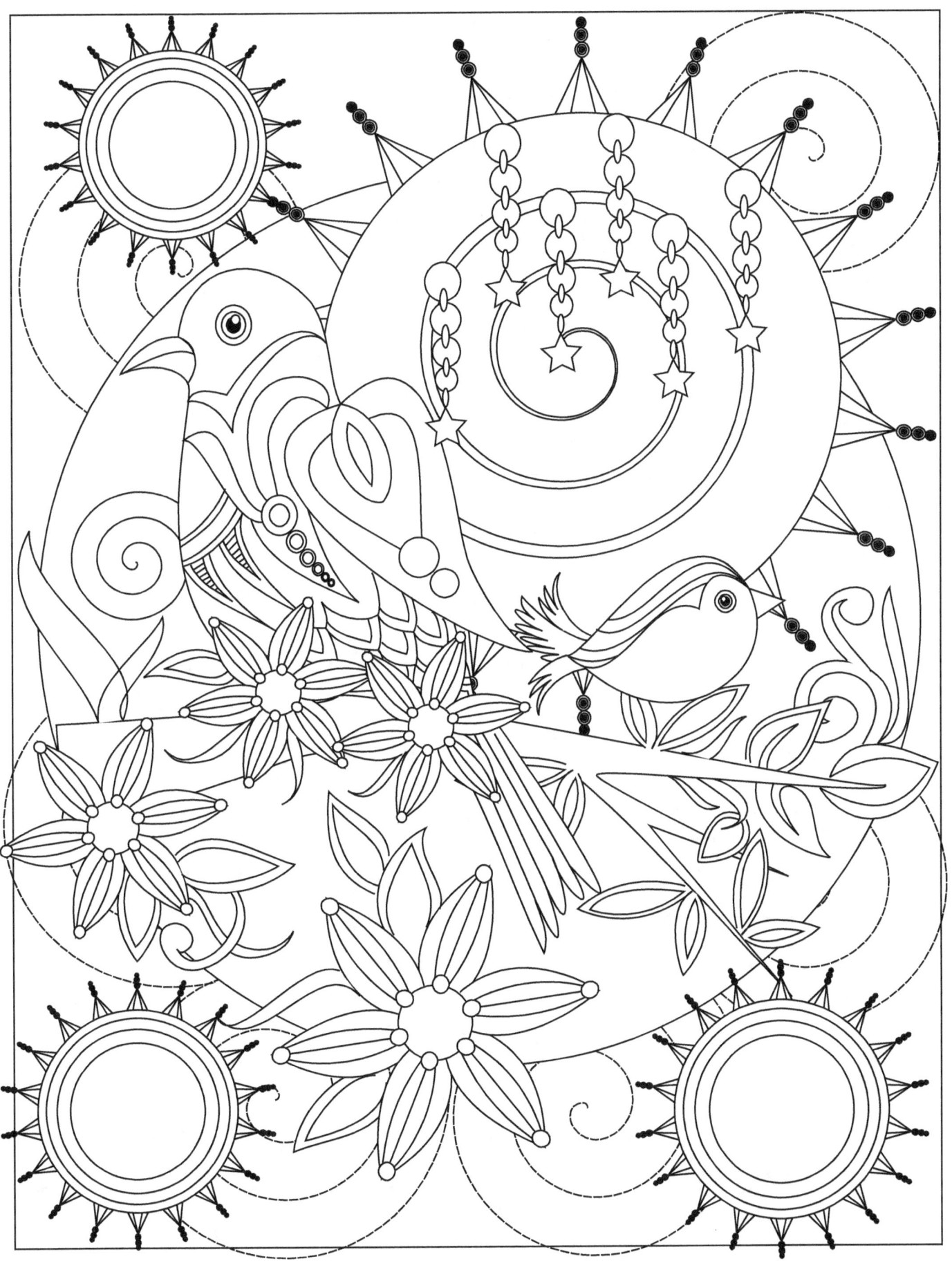

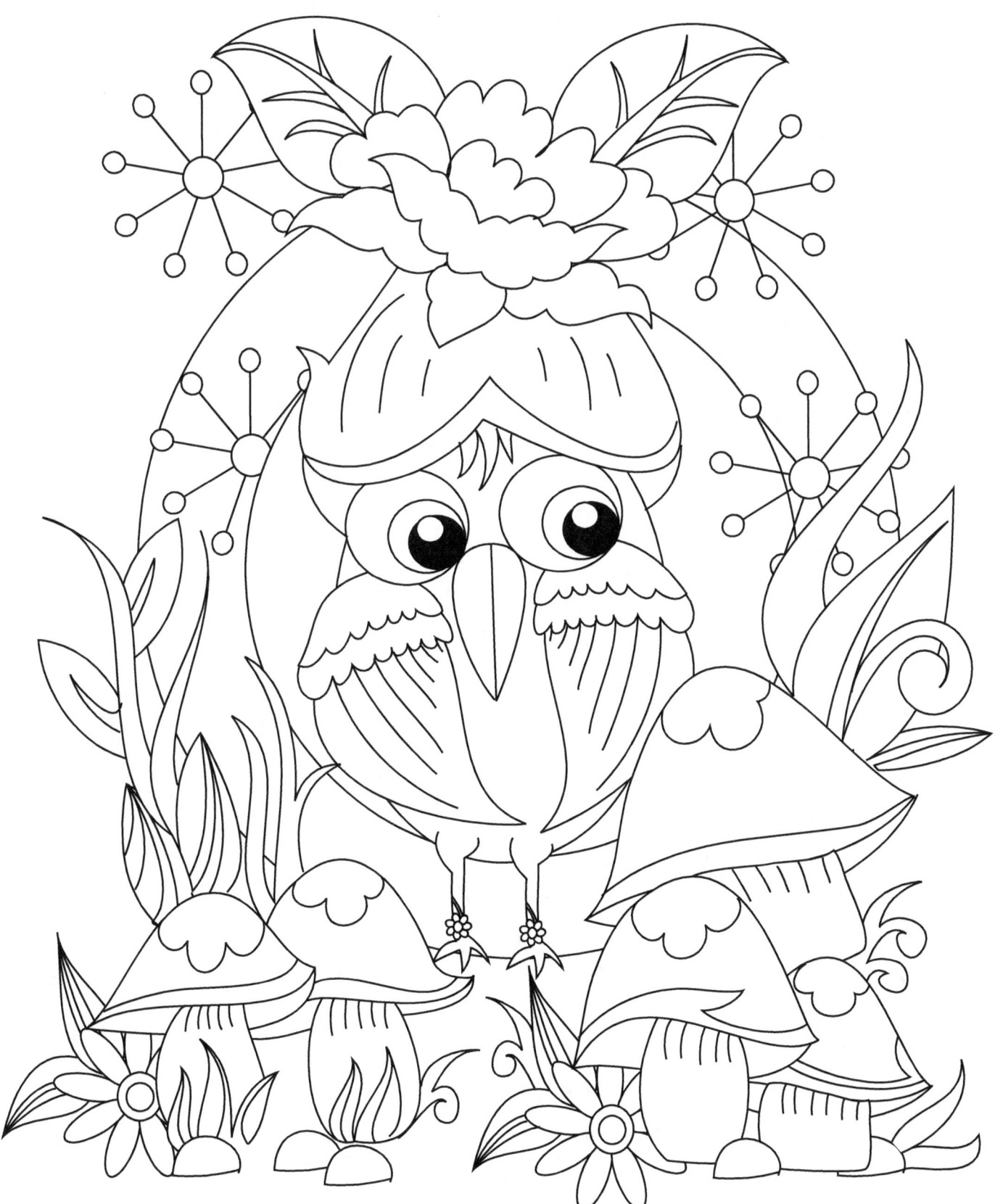

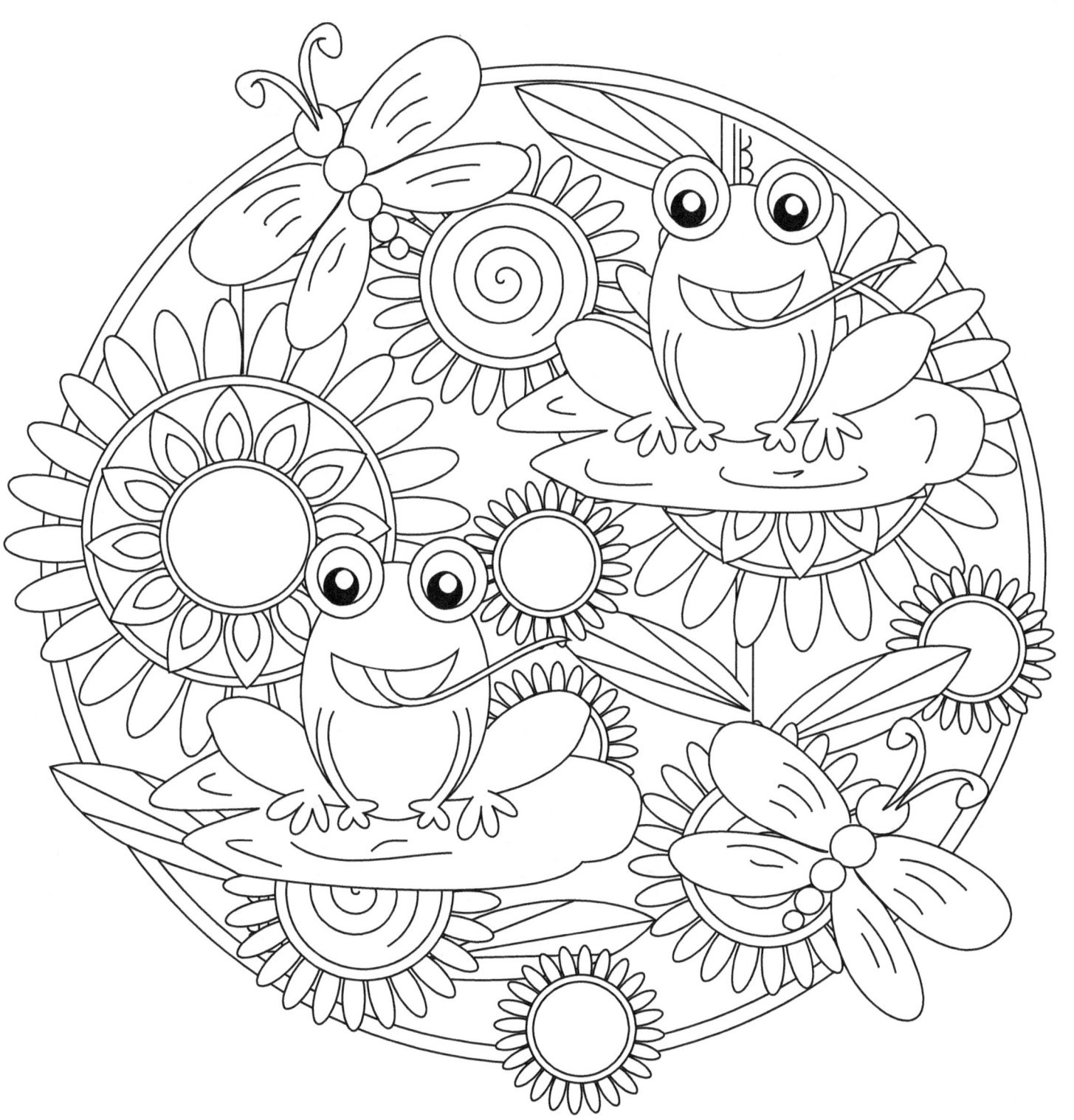

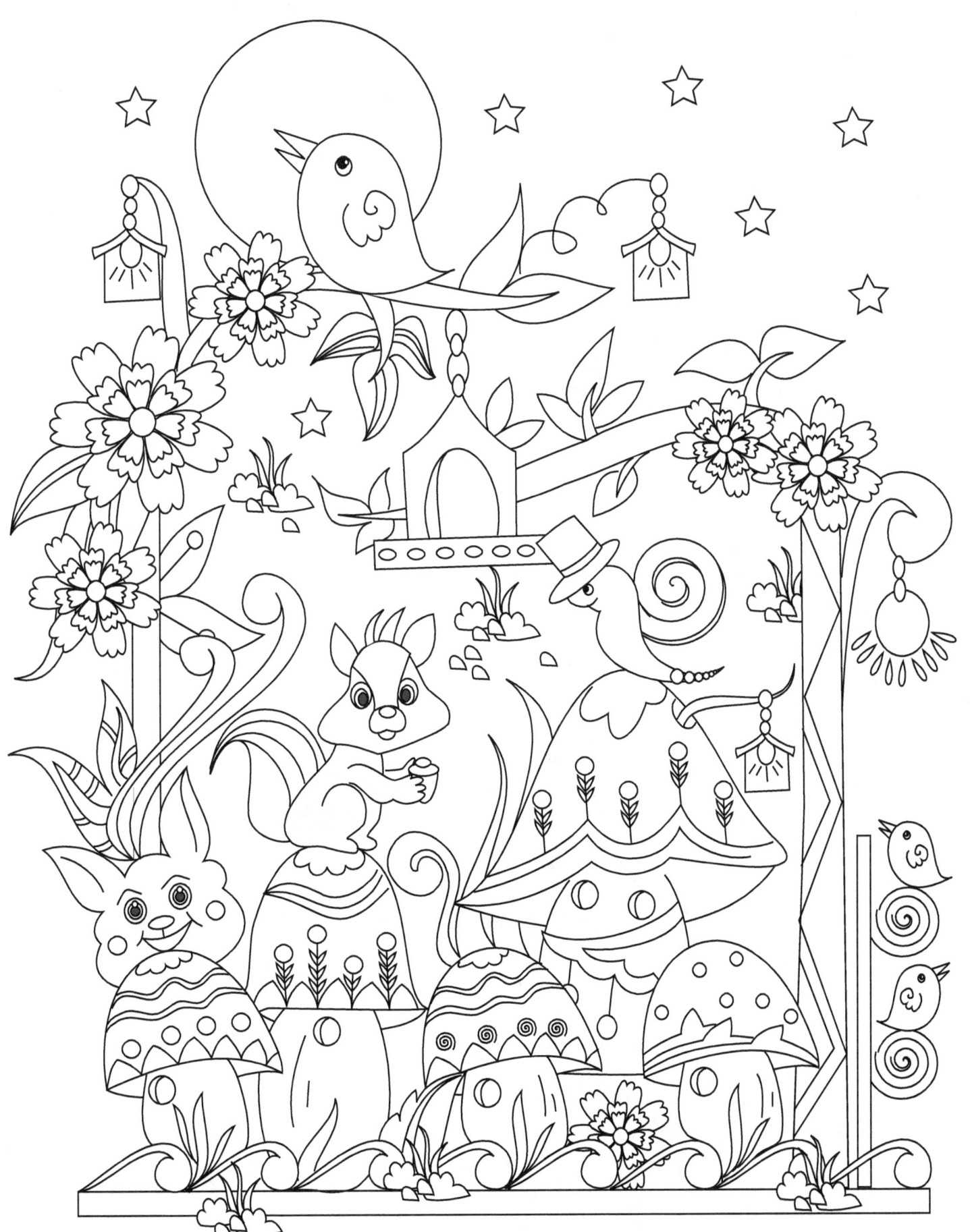

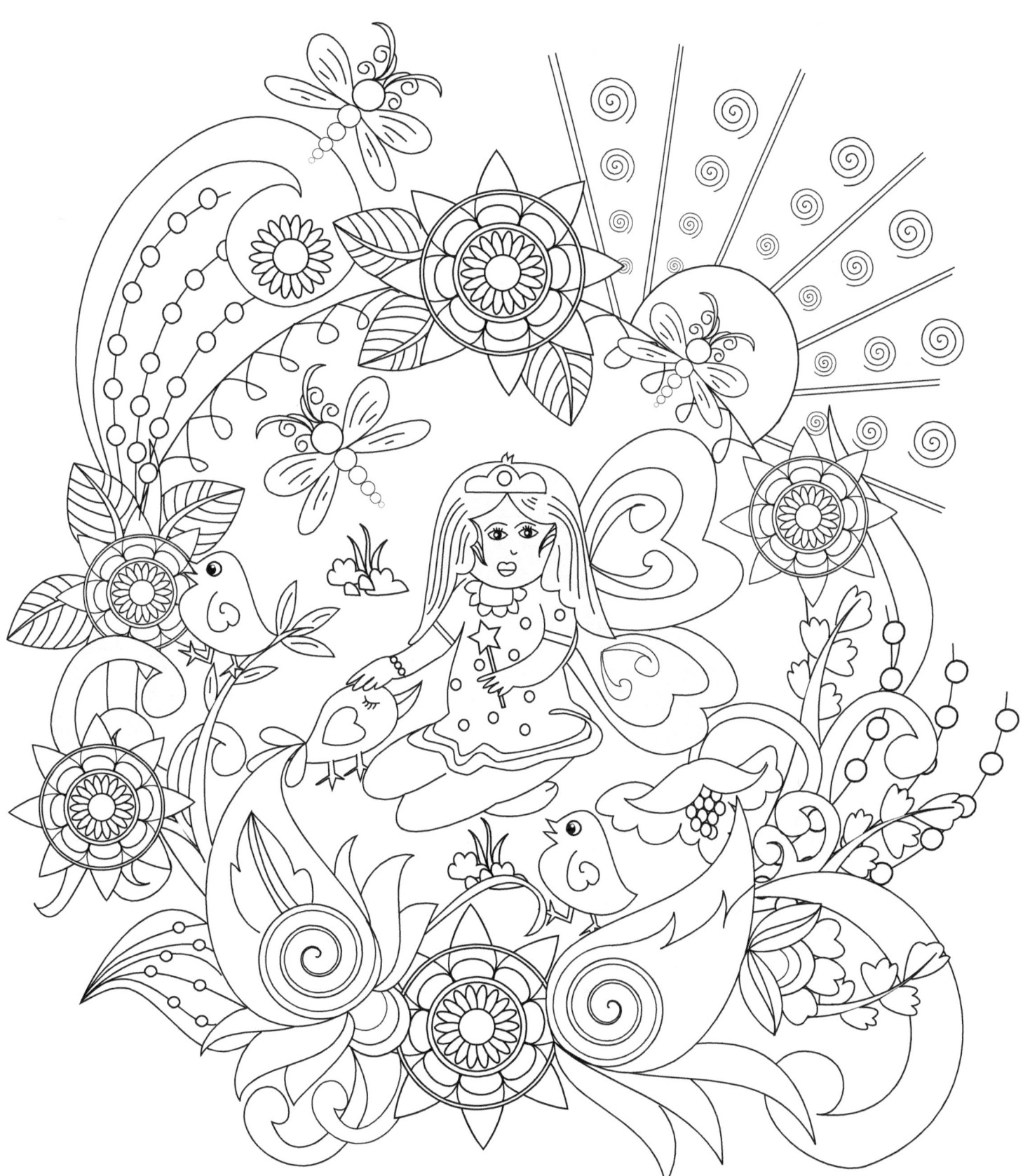

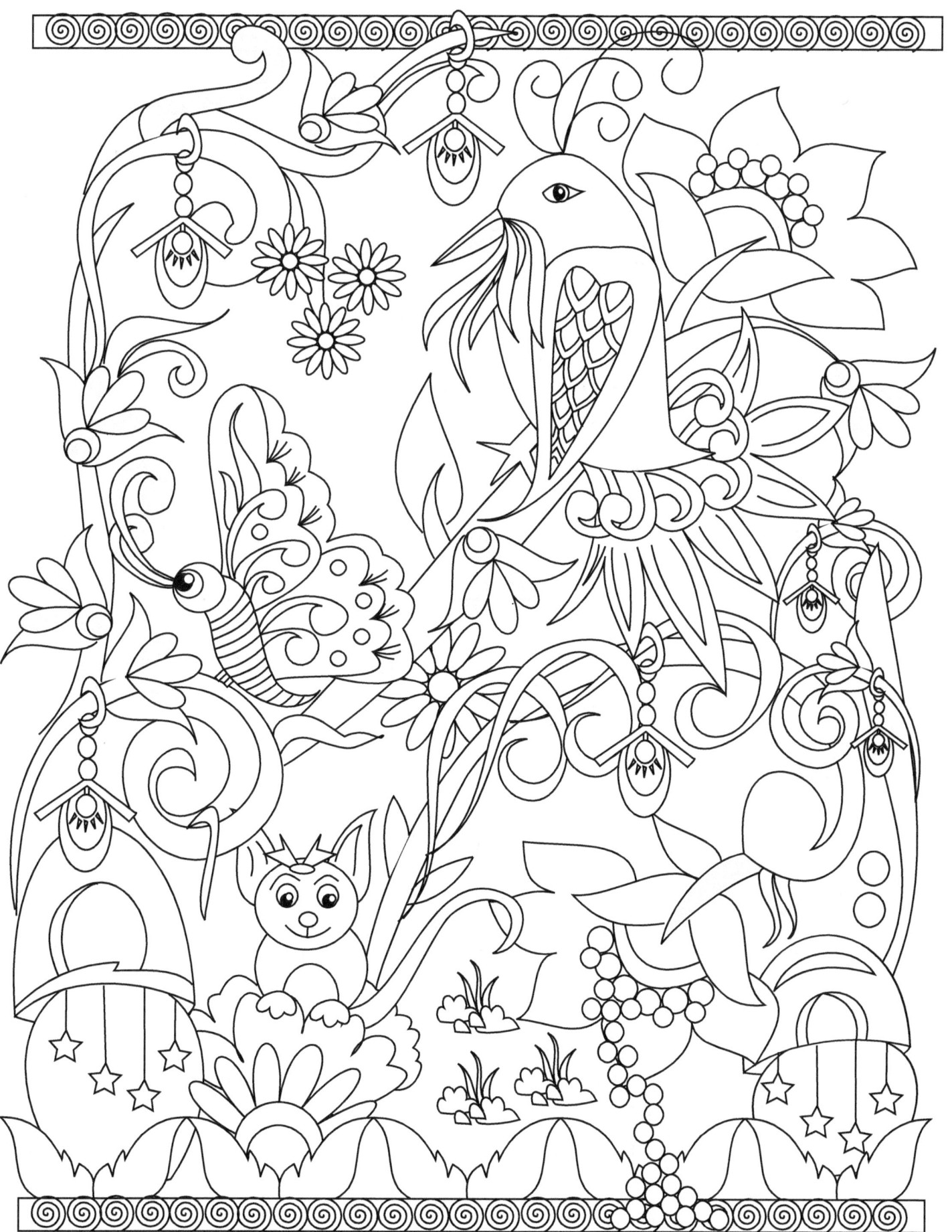

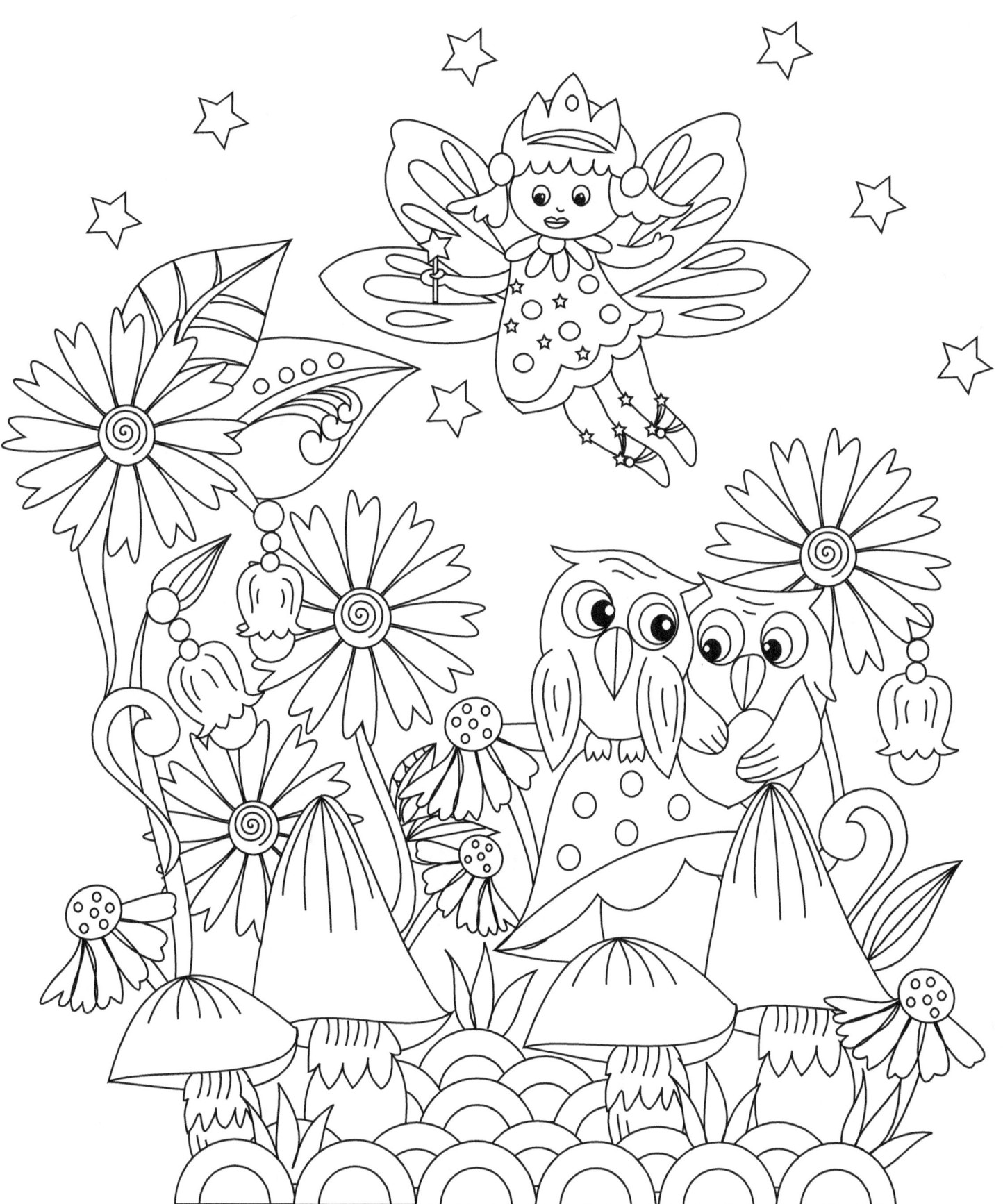

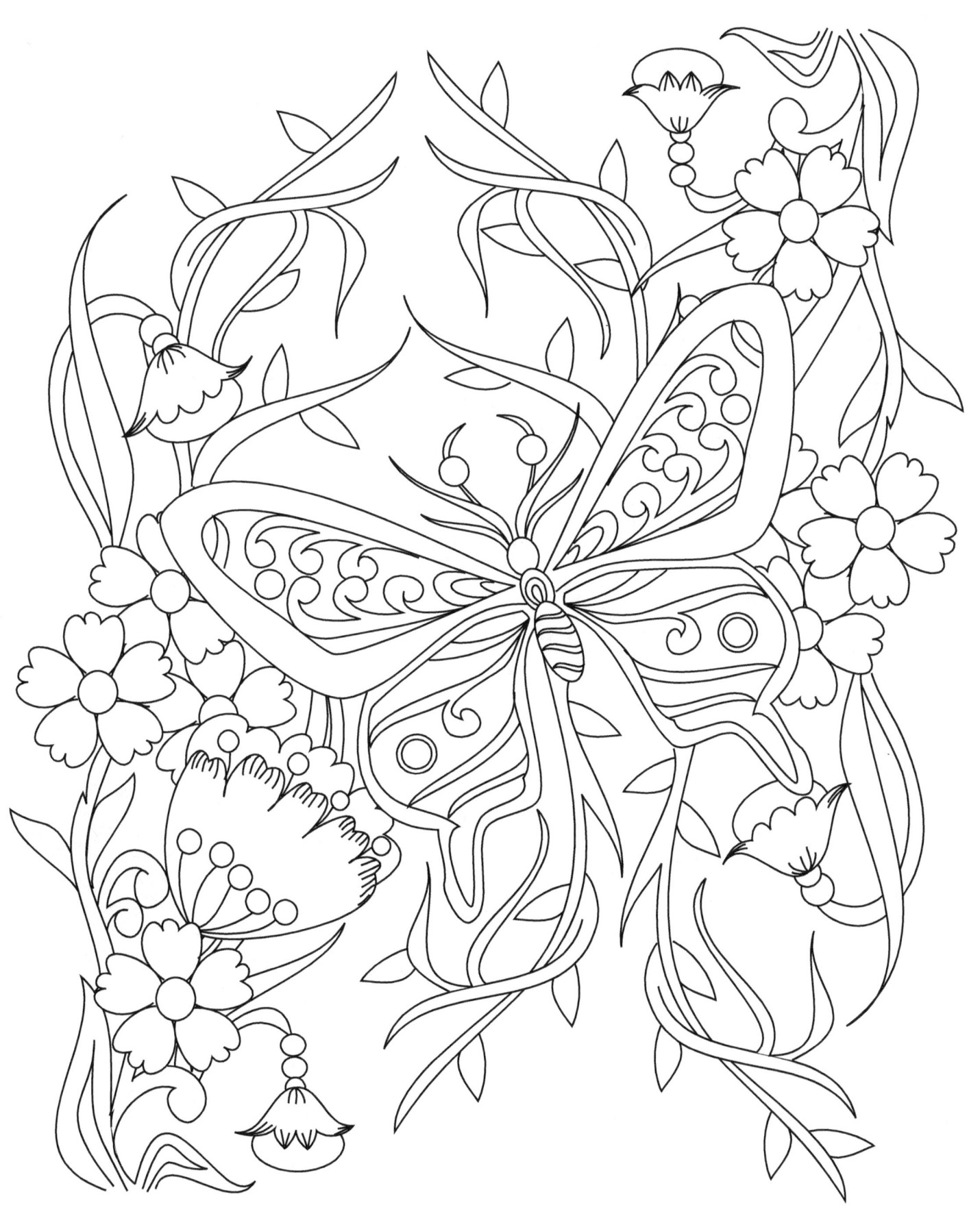

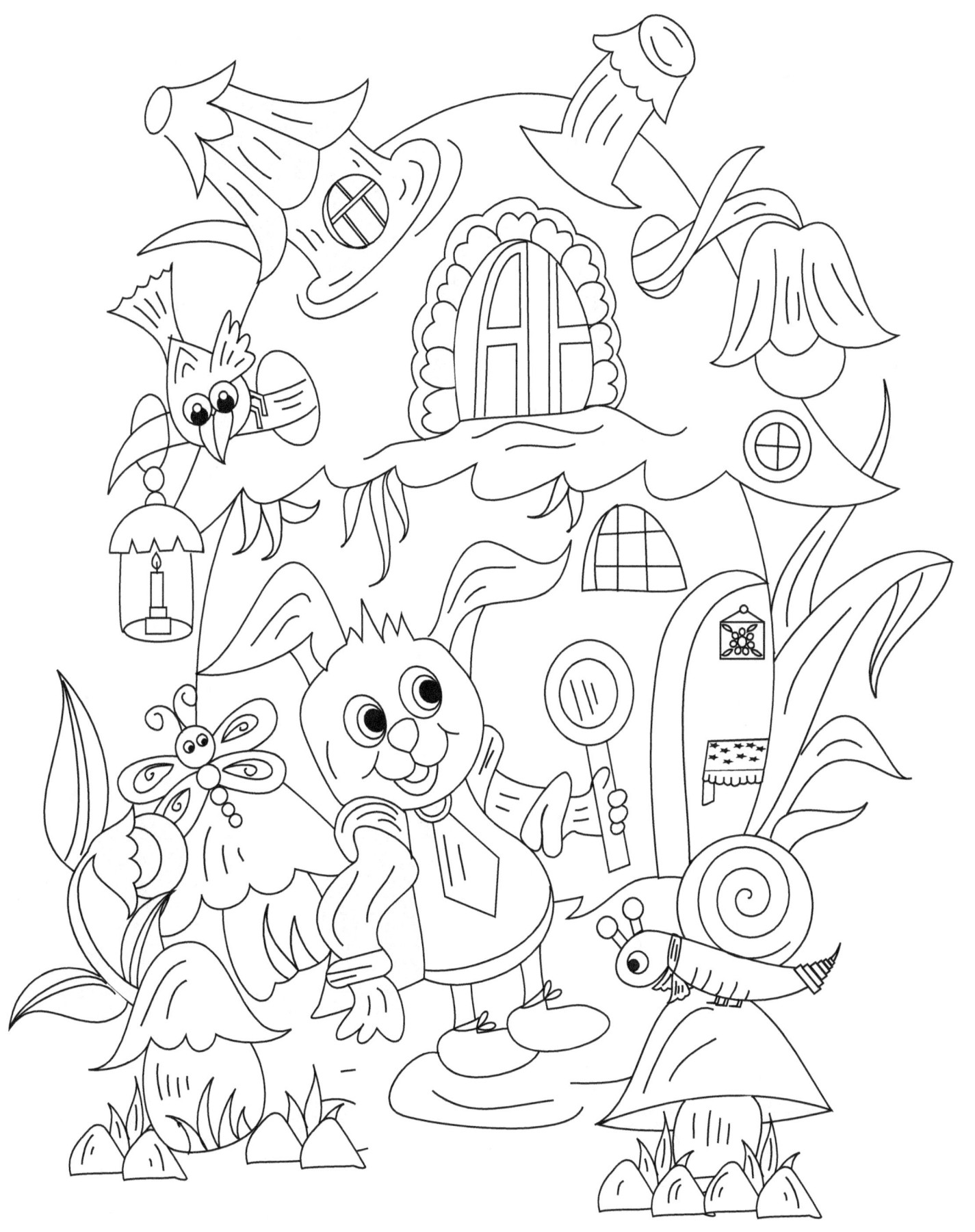

Color test

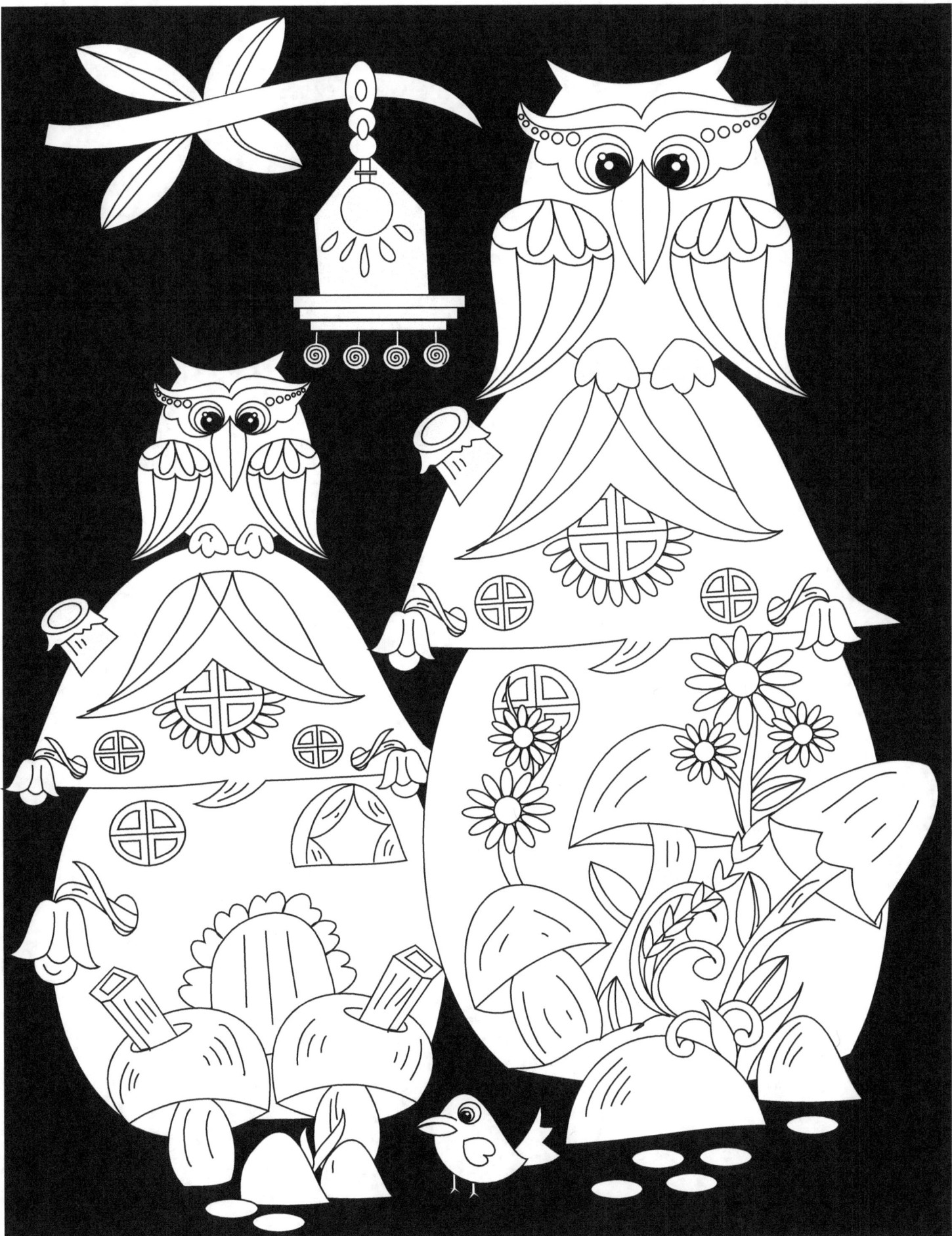

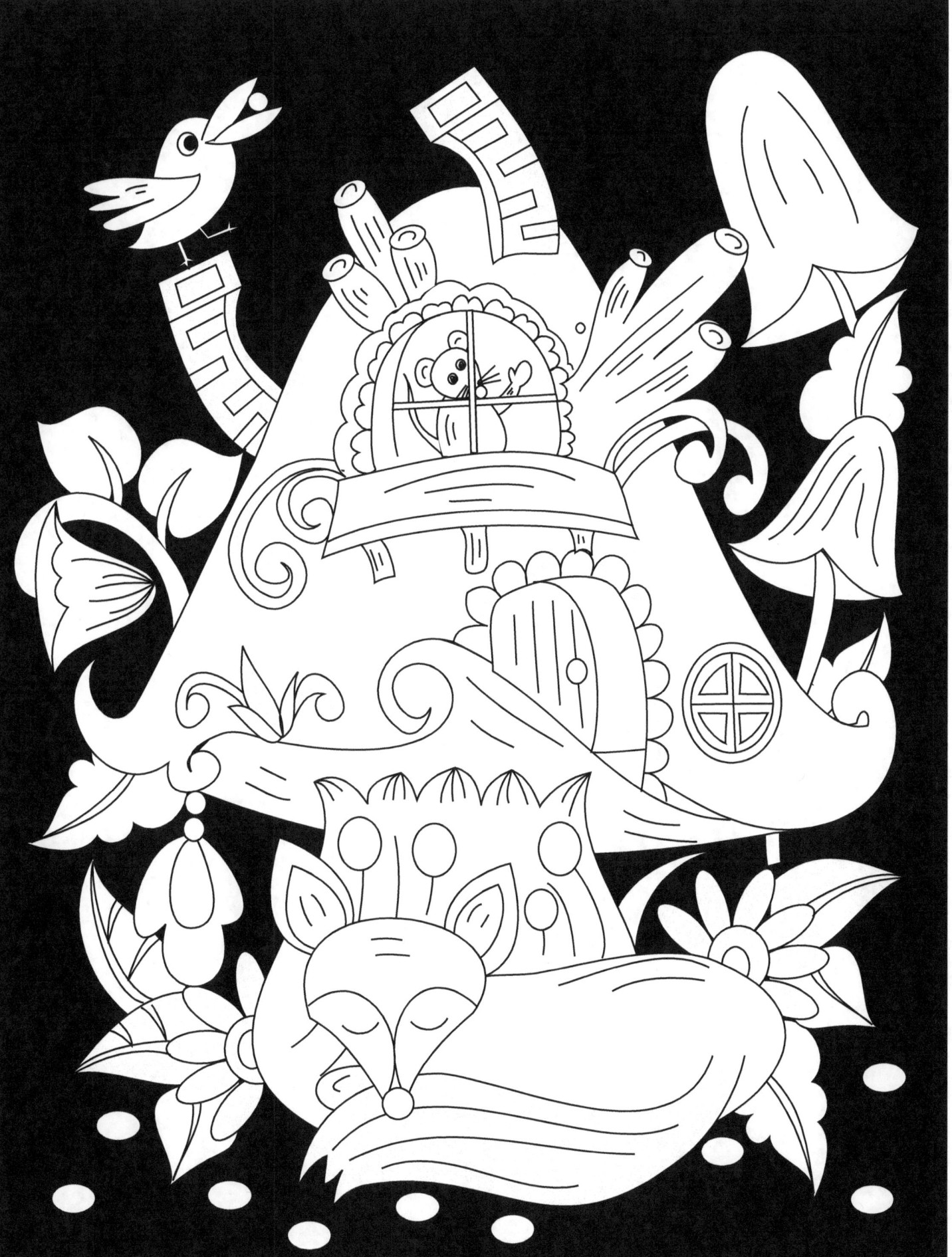

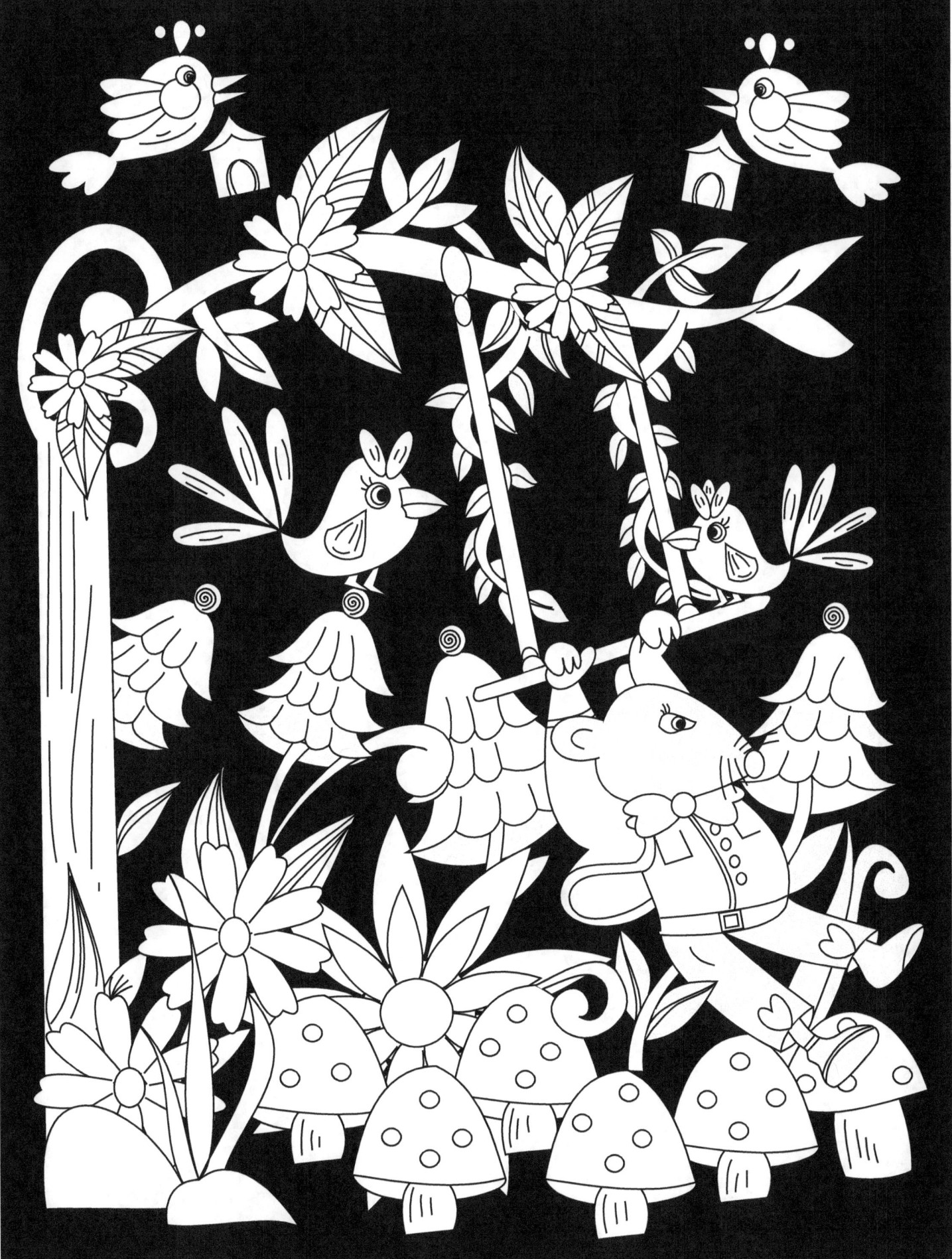

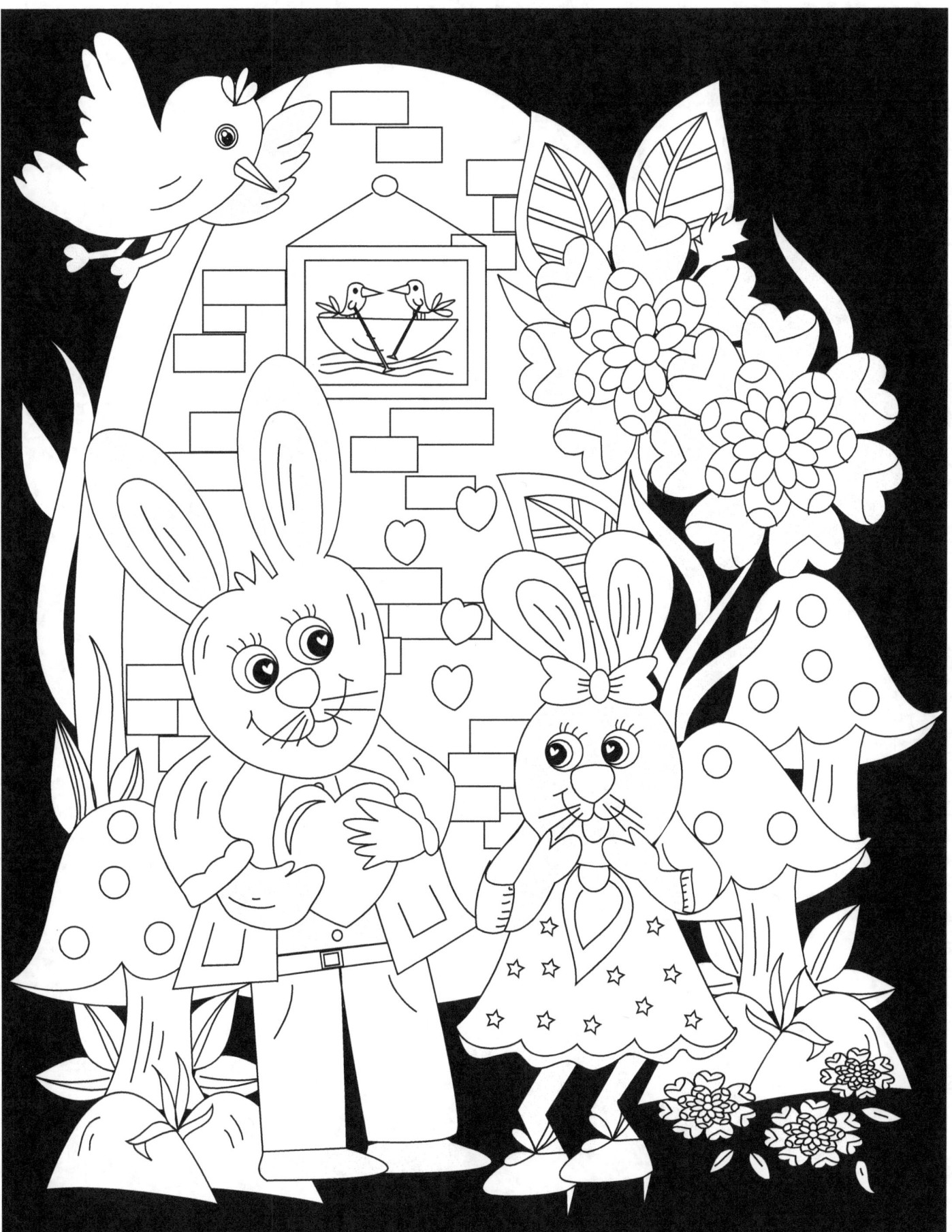

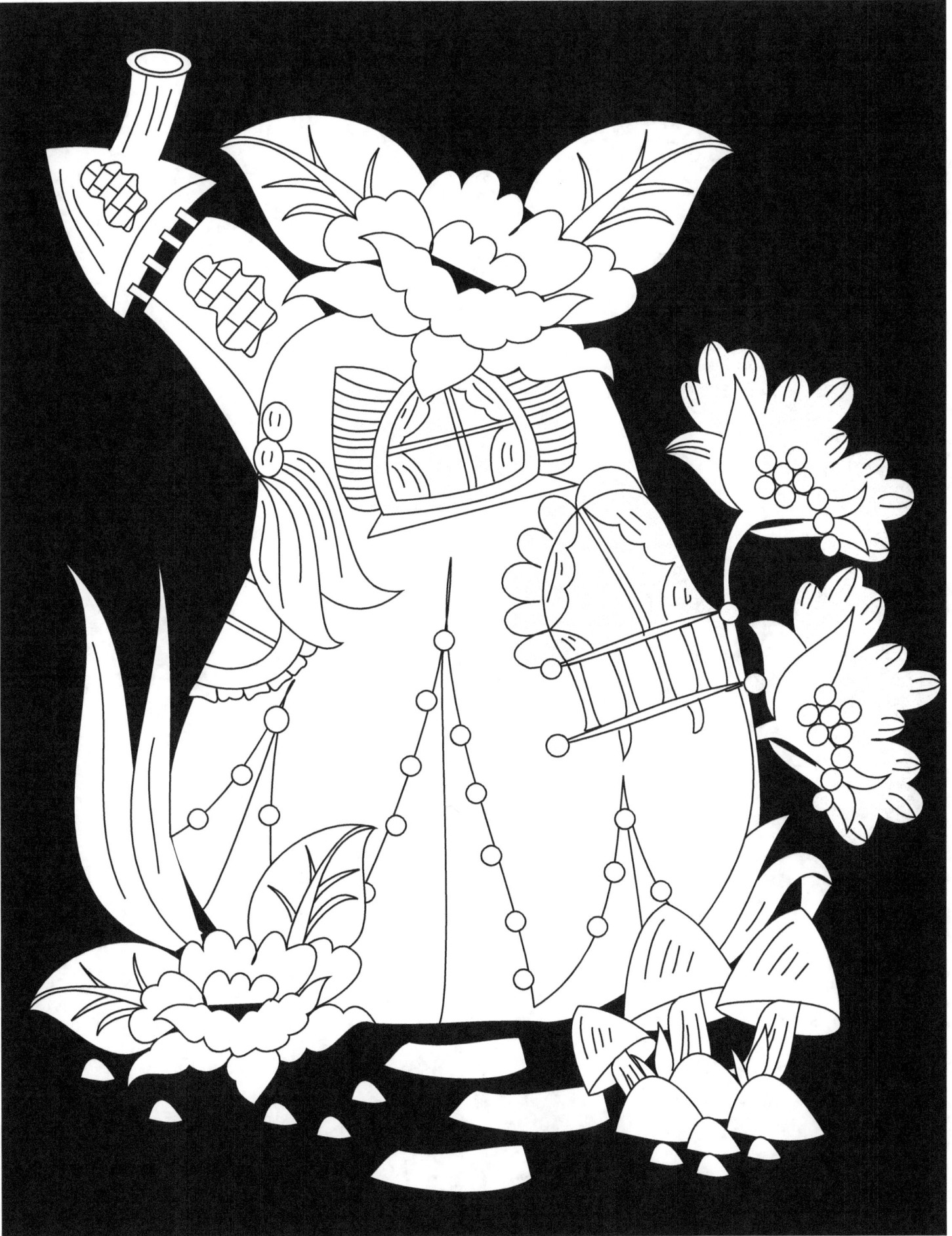

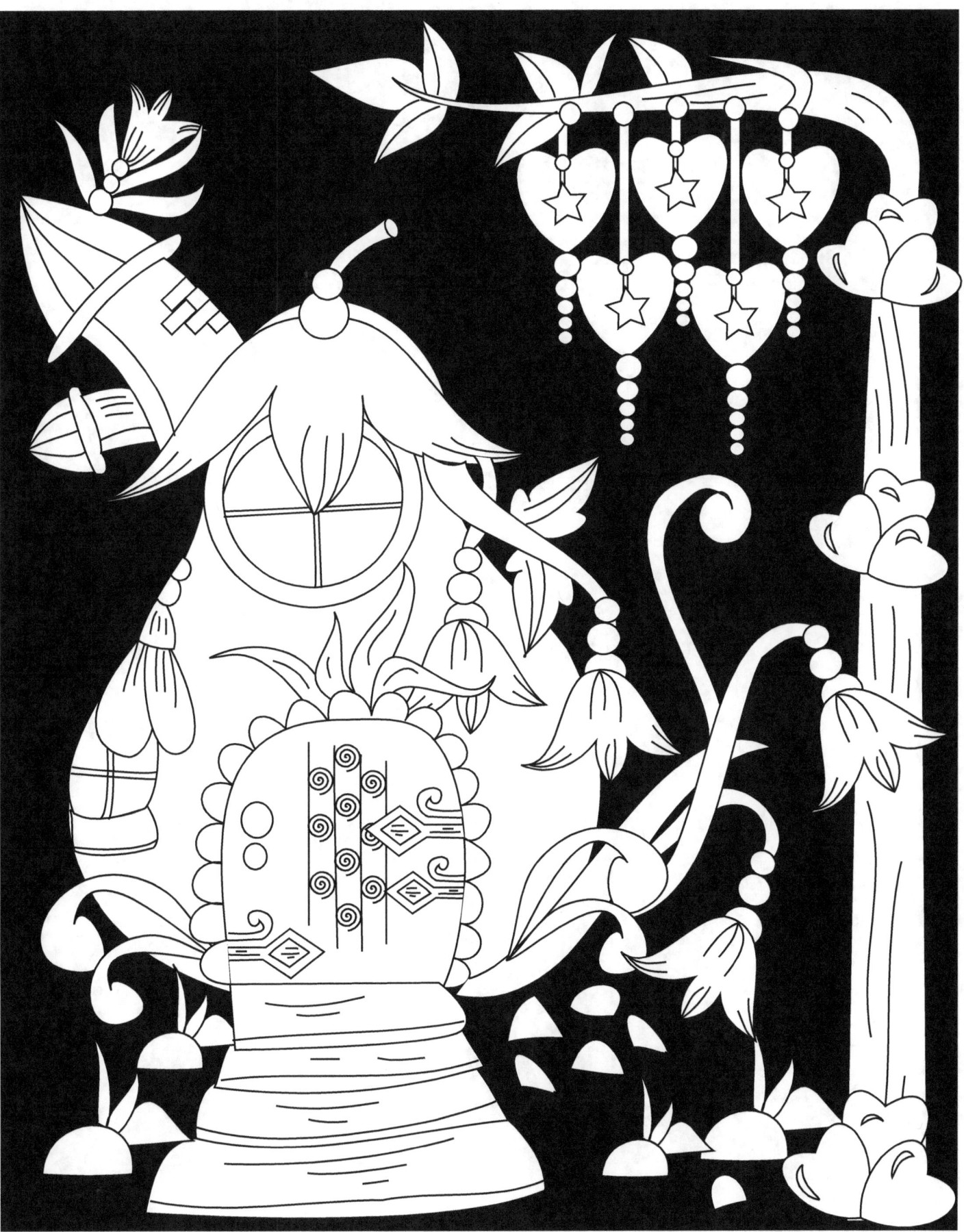

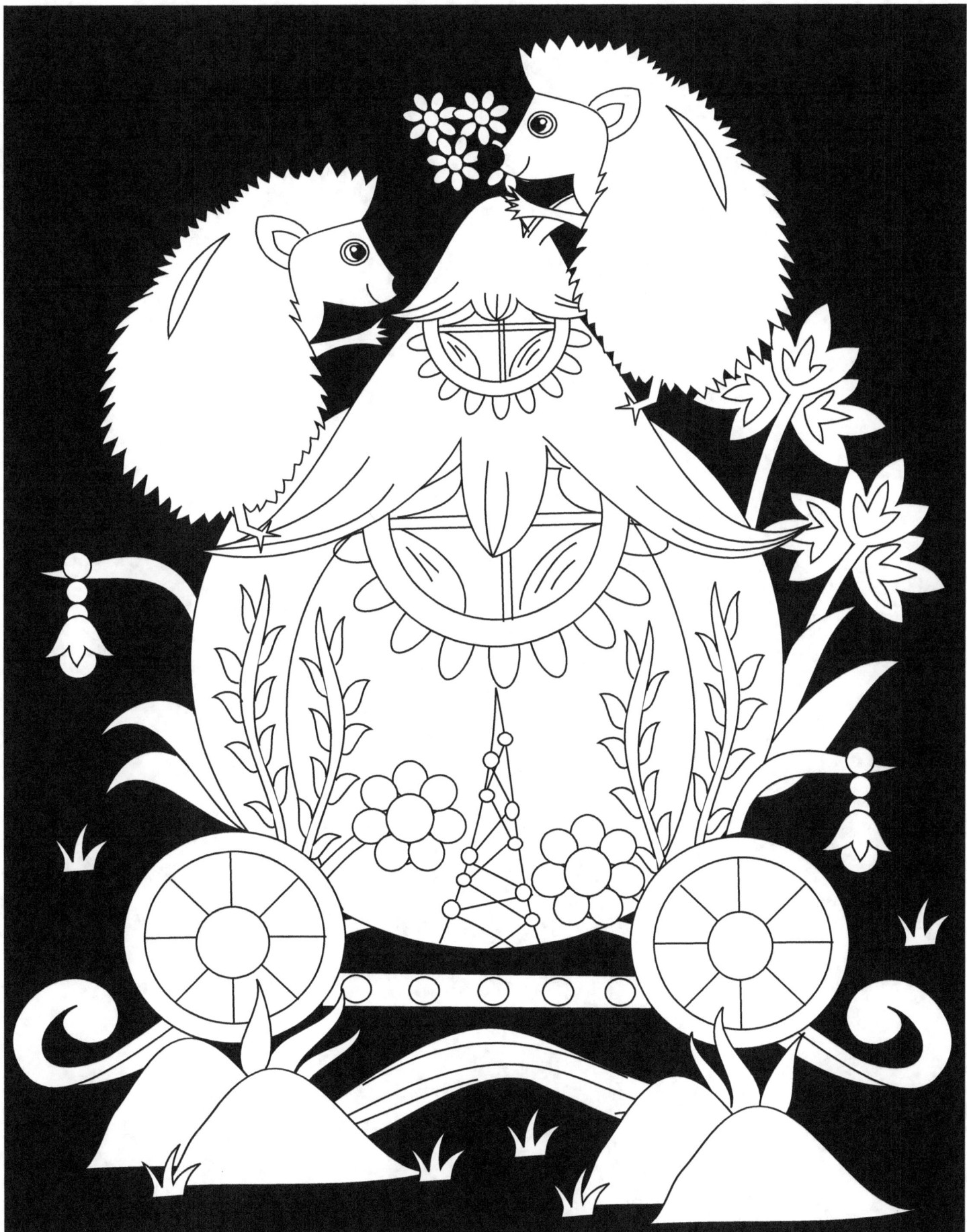

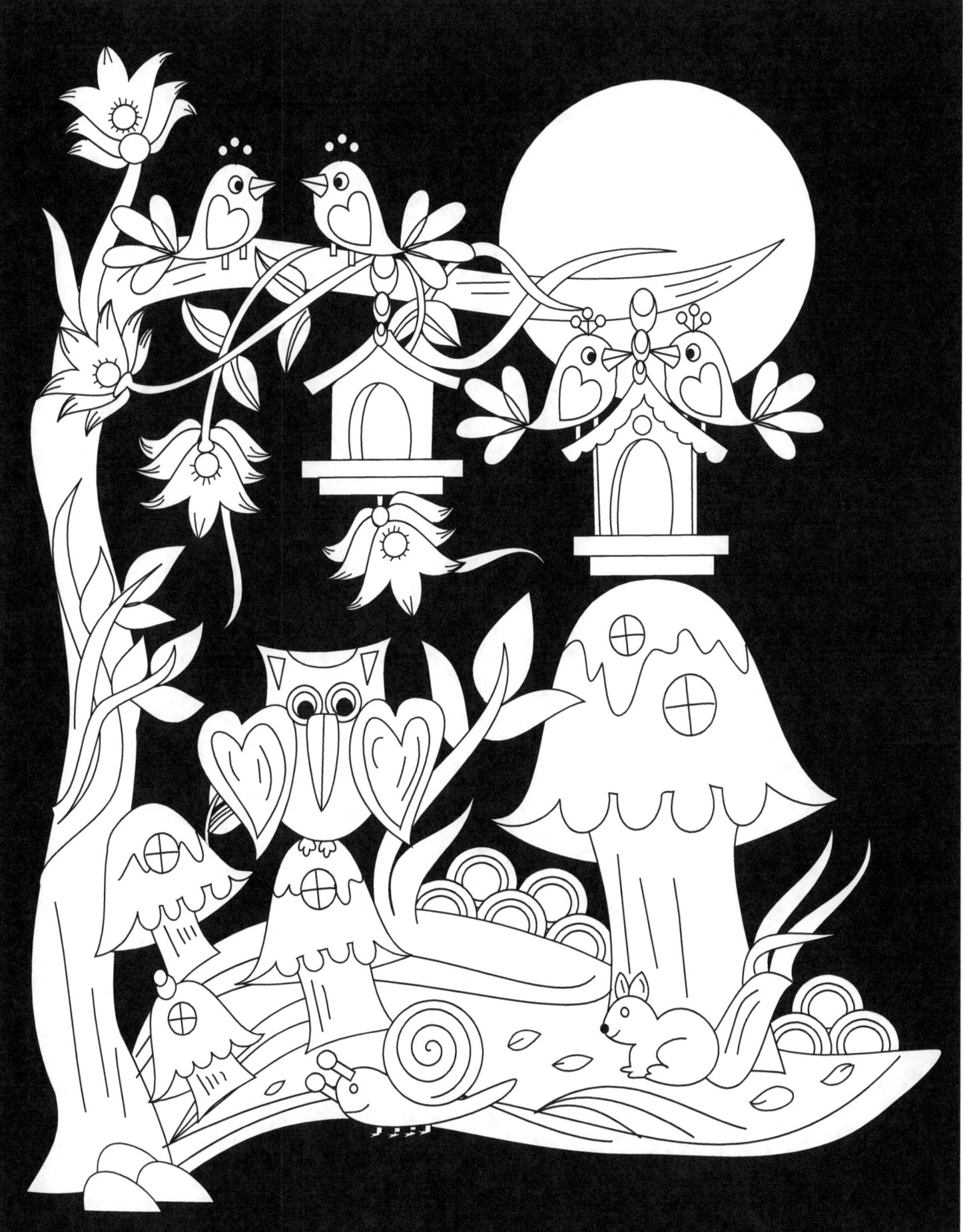

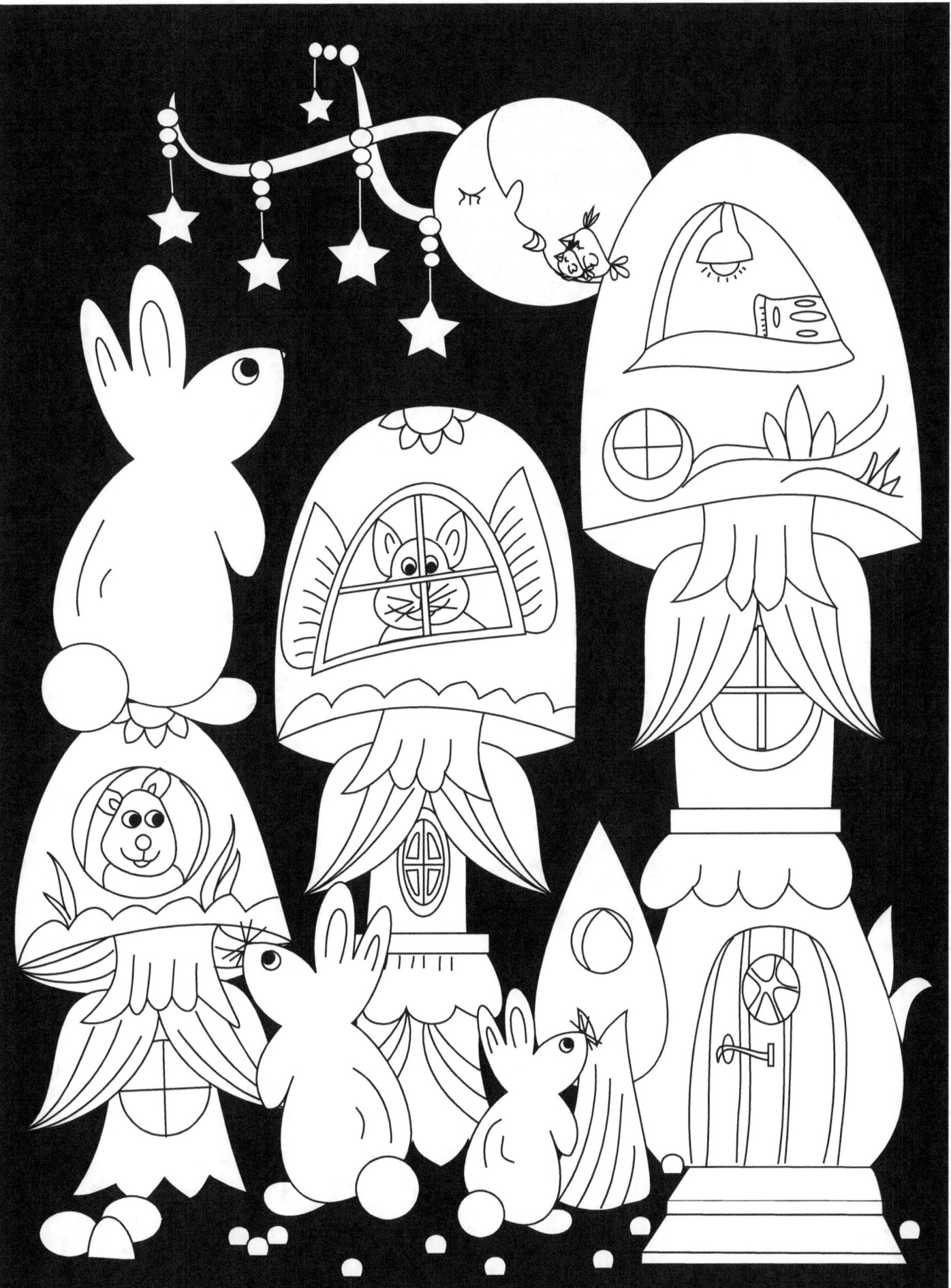

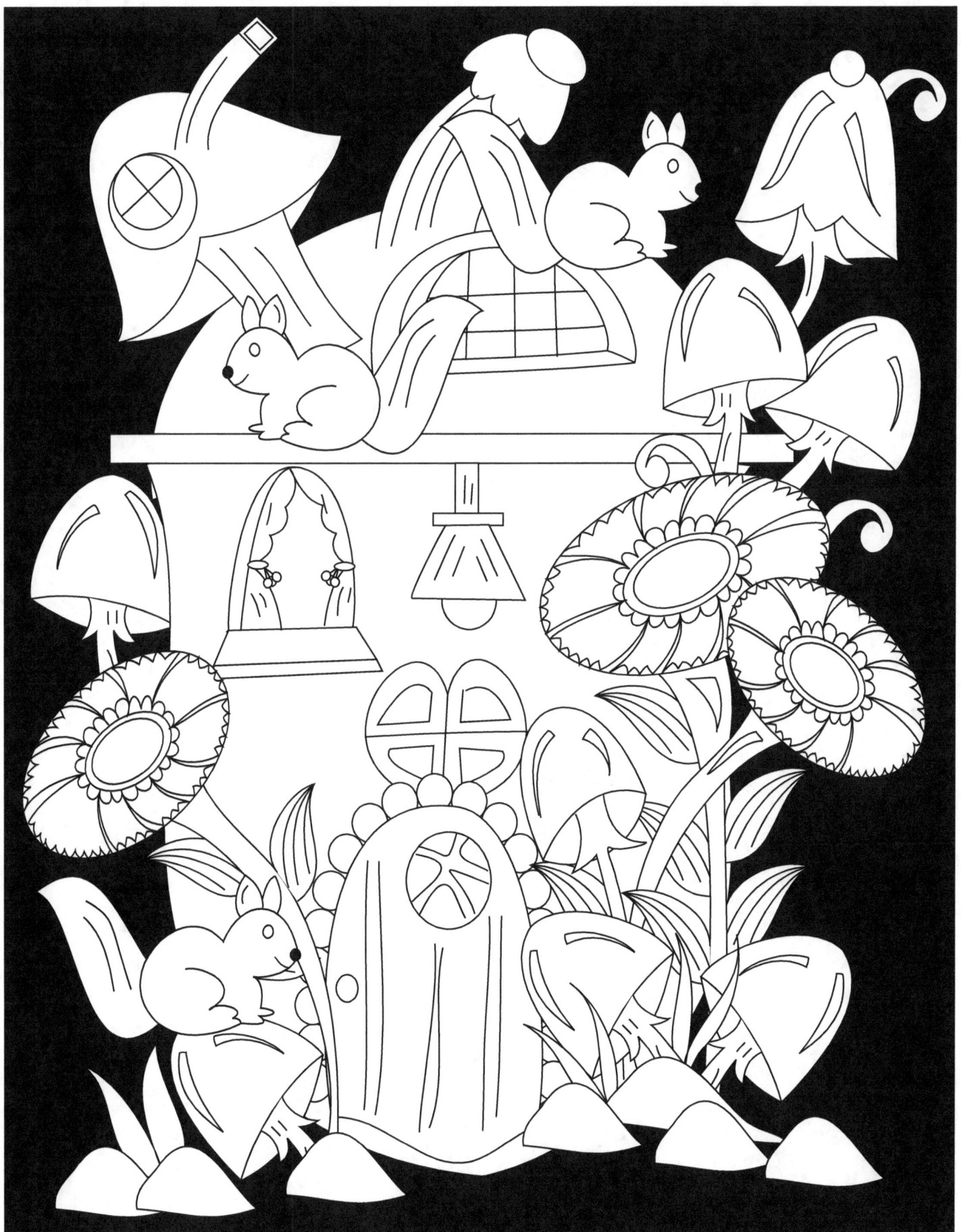

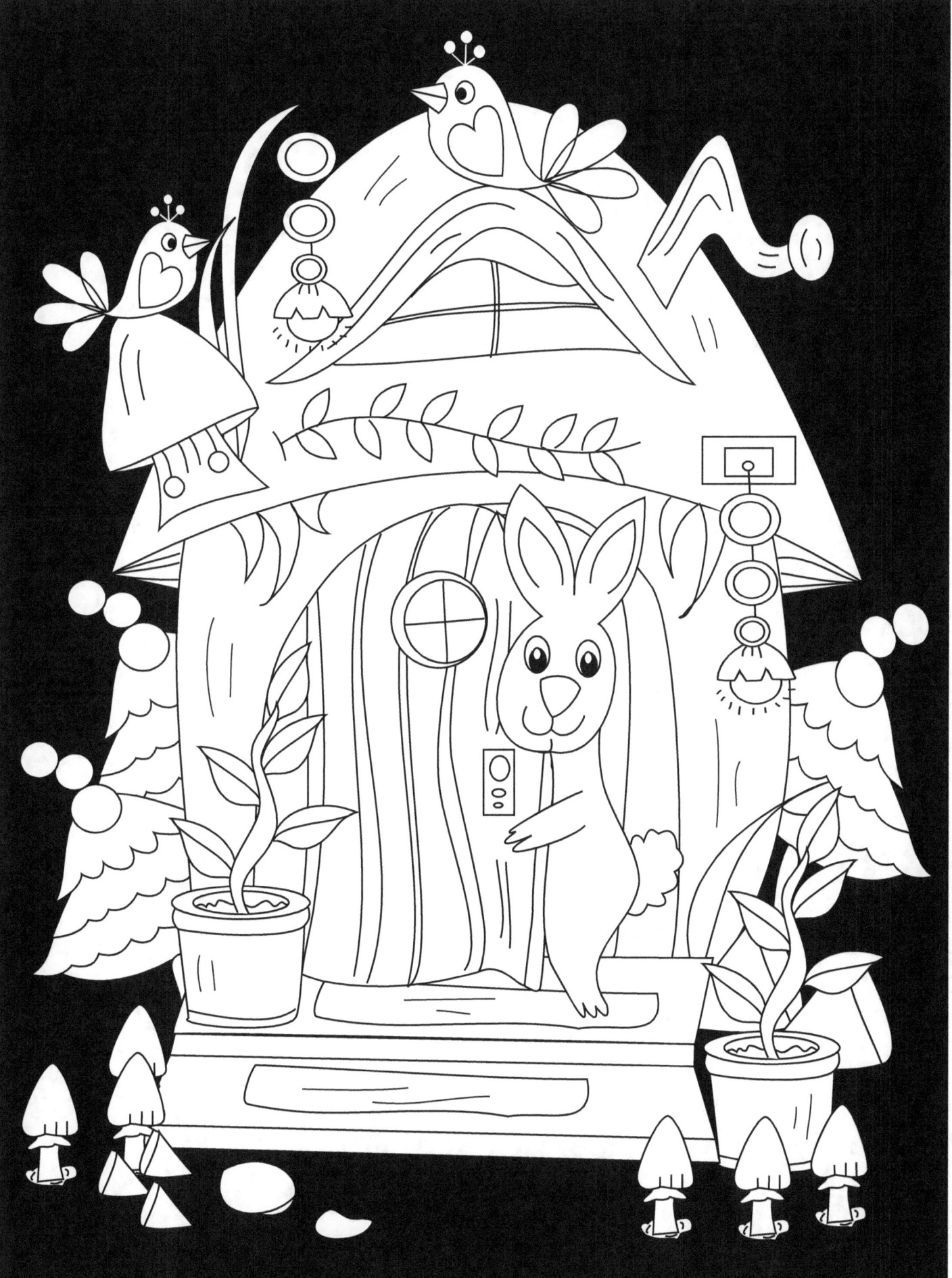

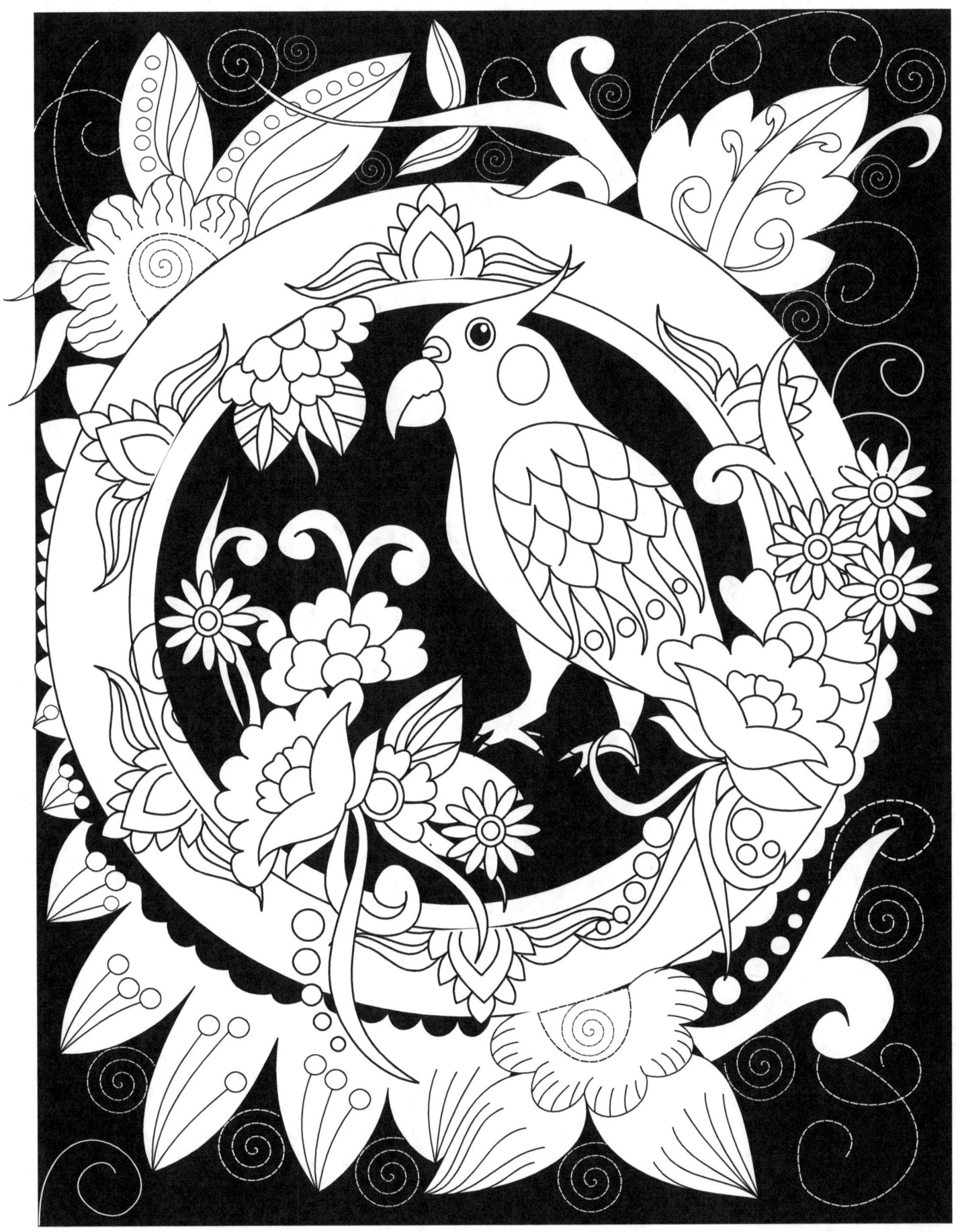

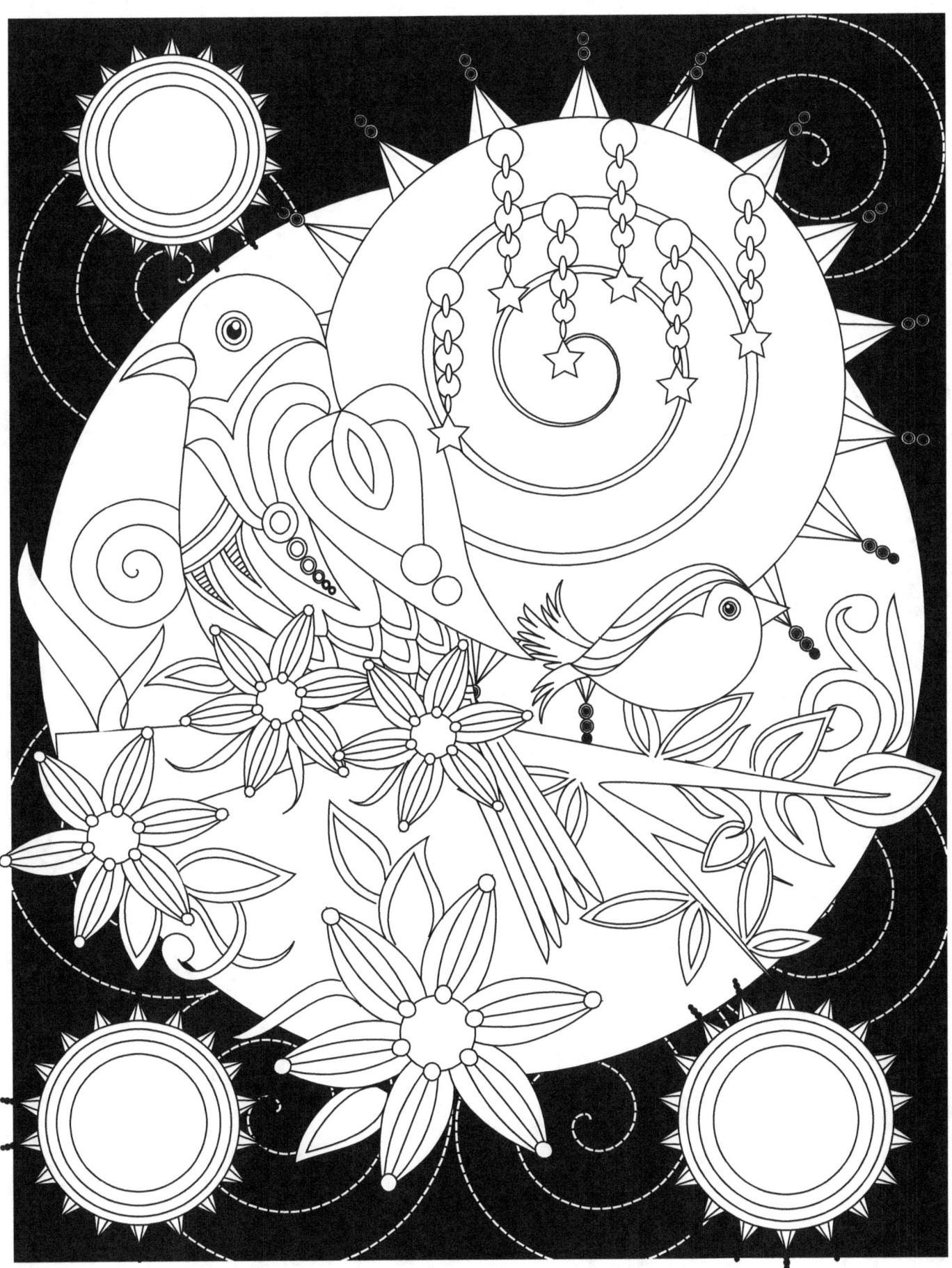

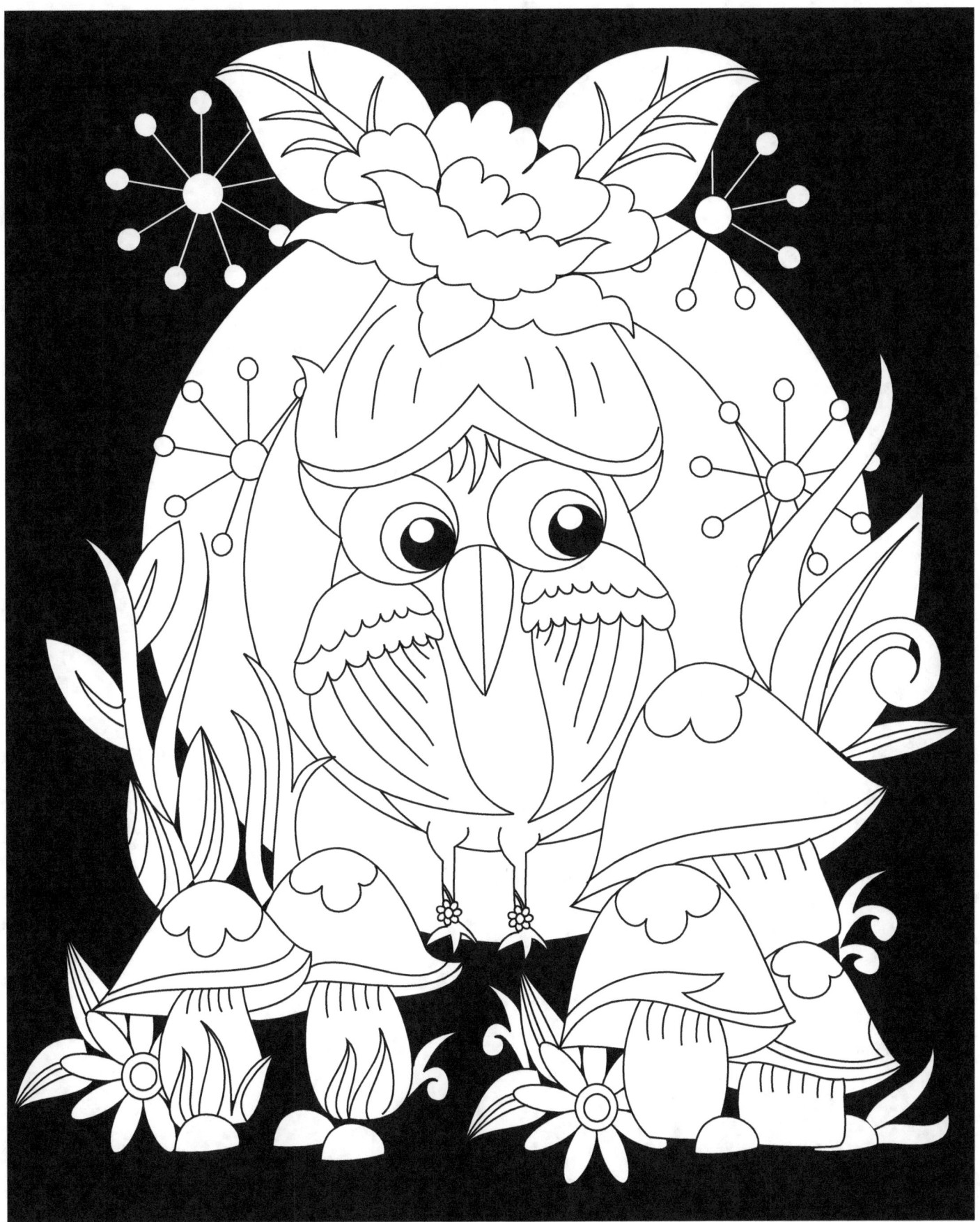

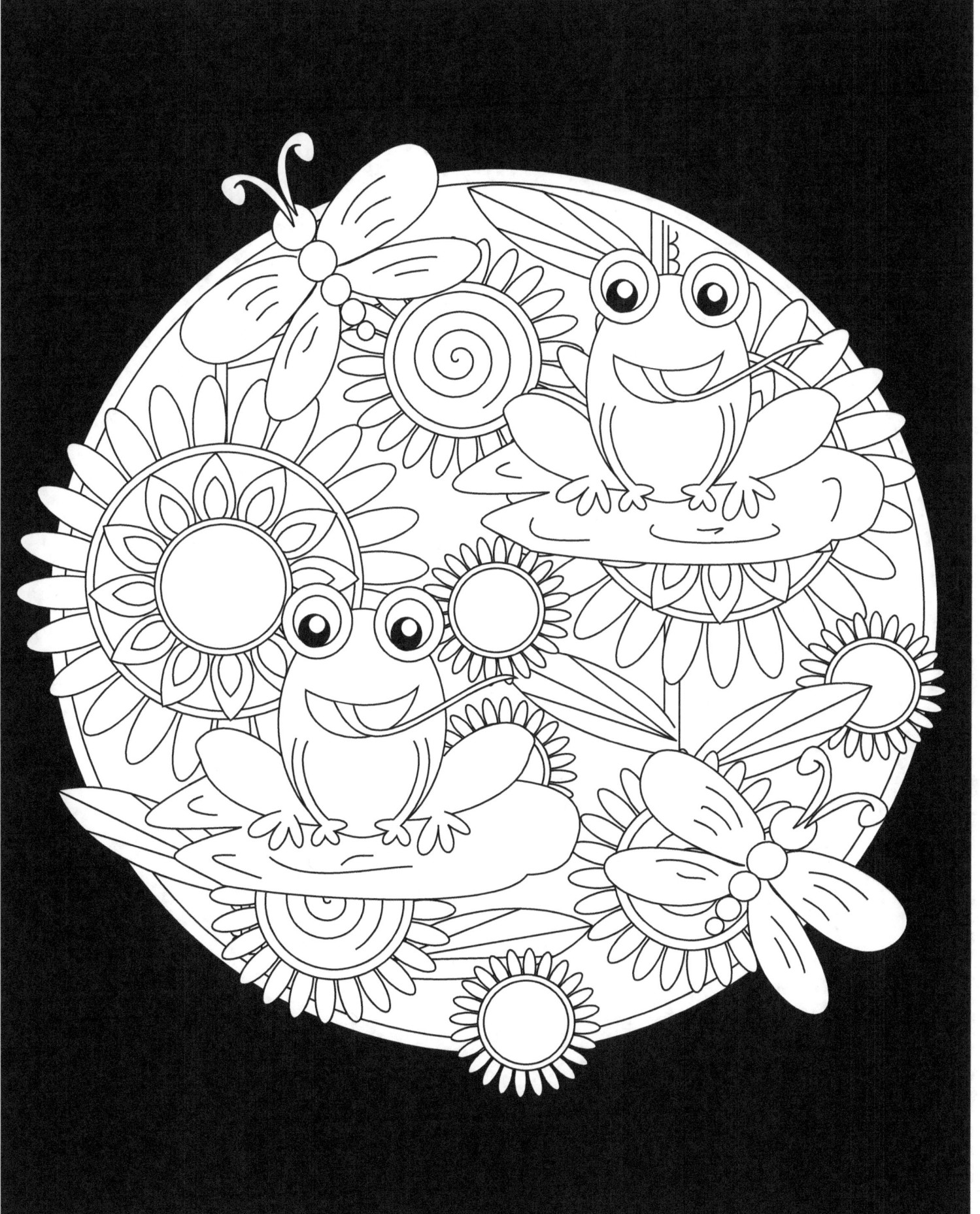

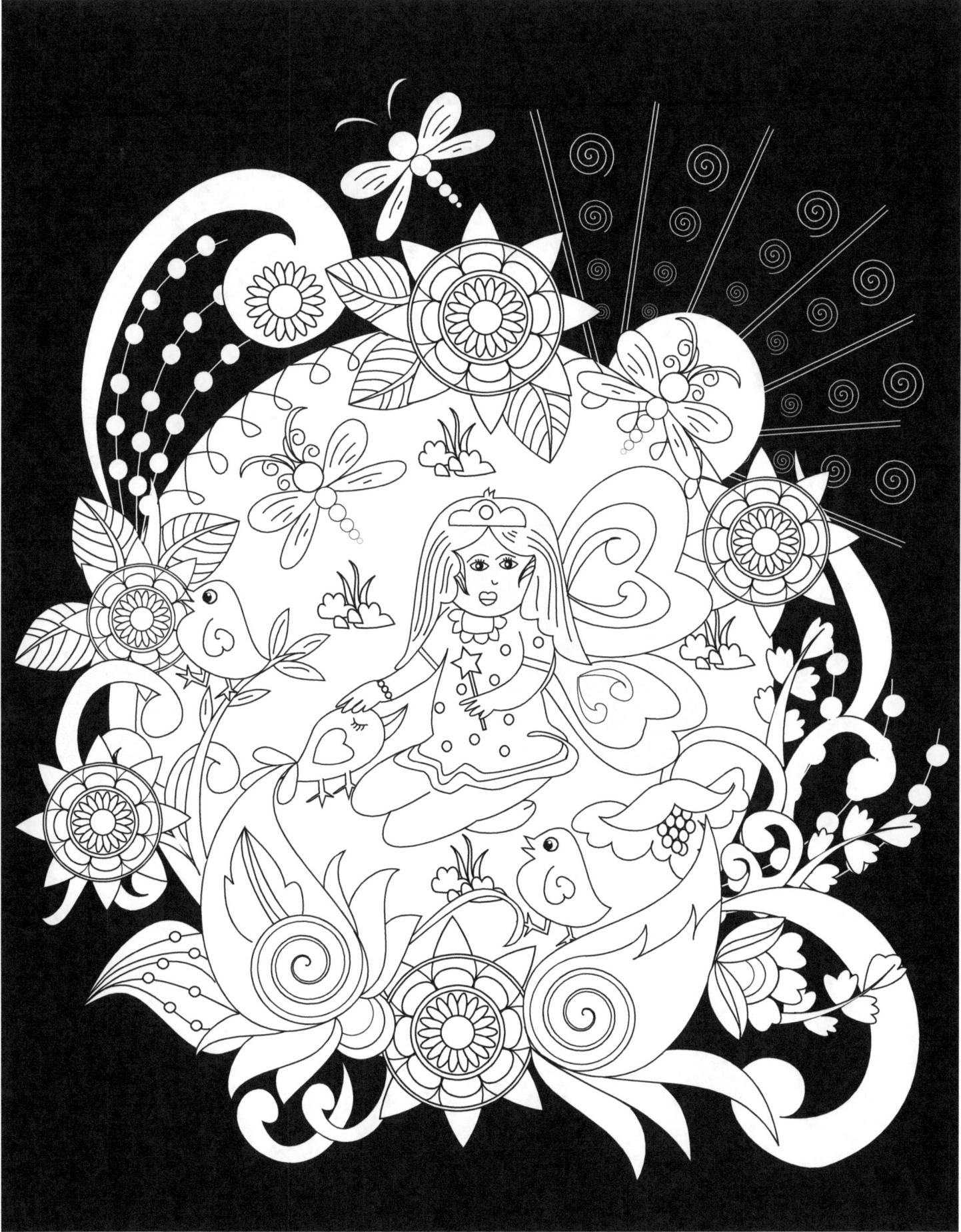

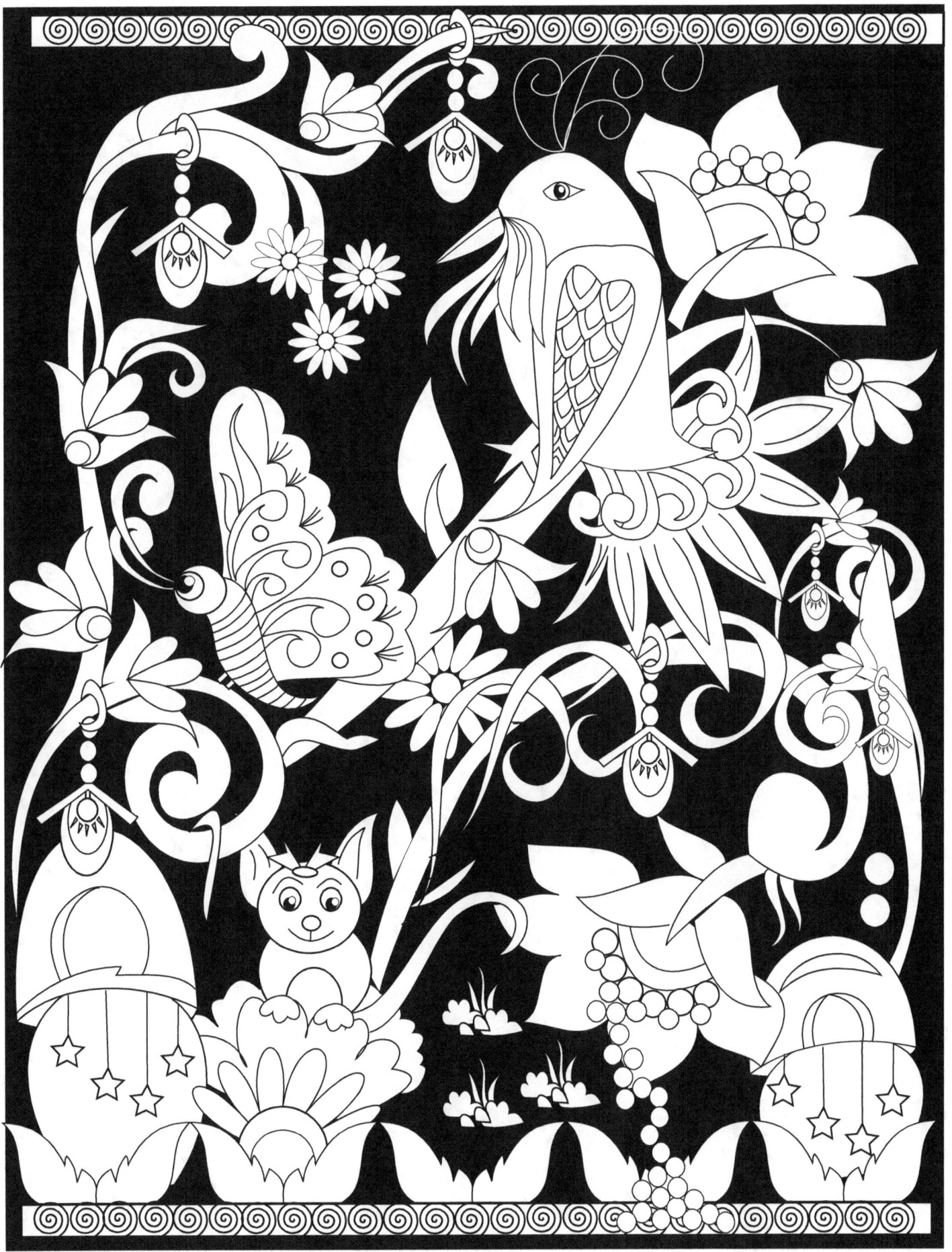

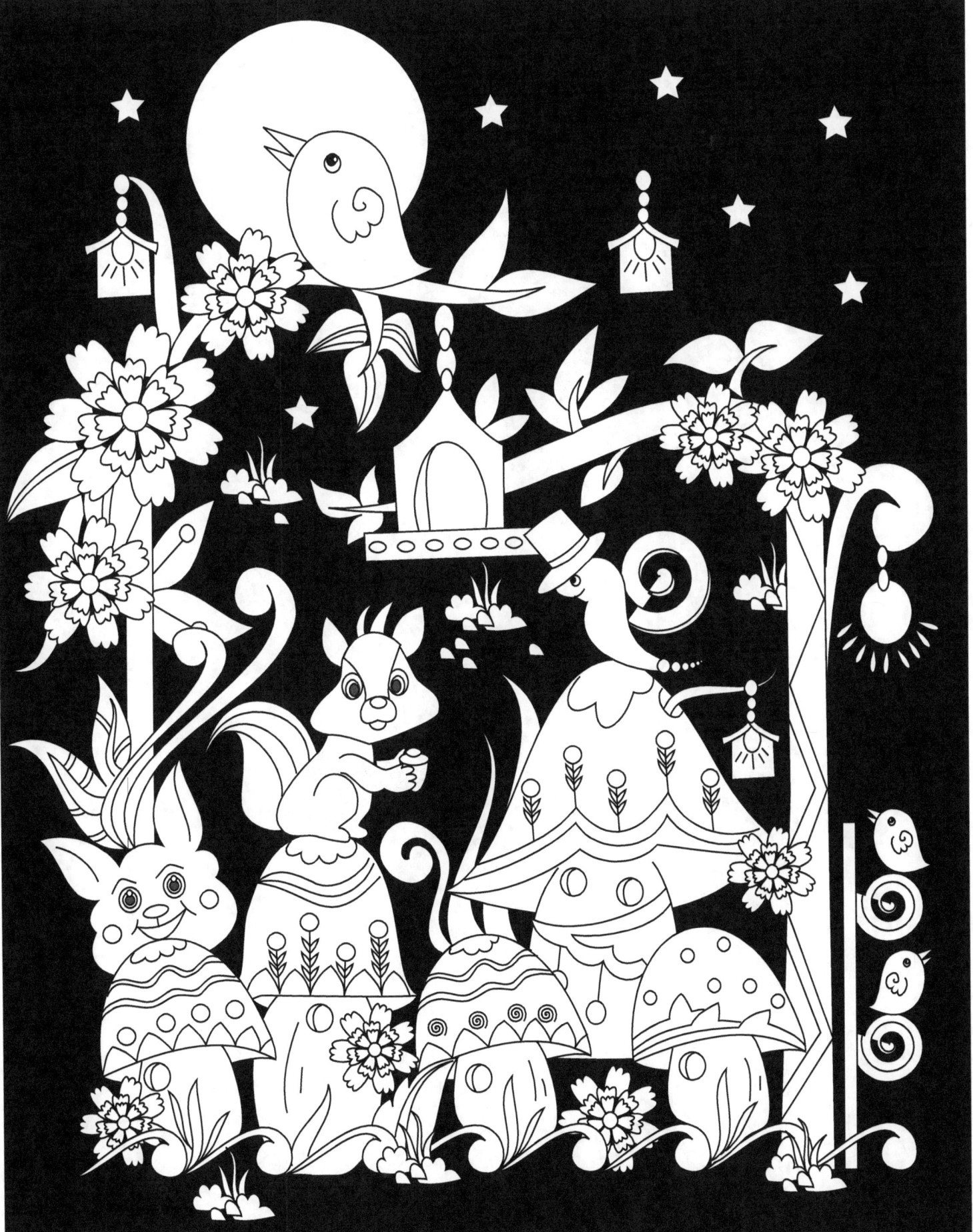

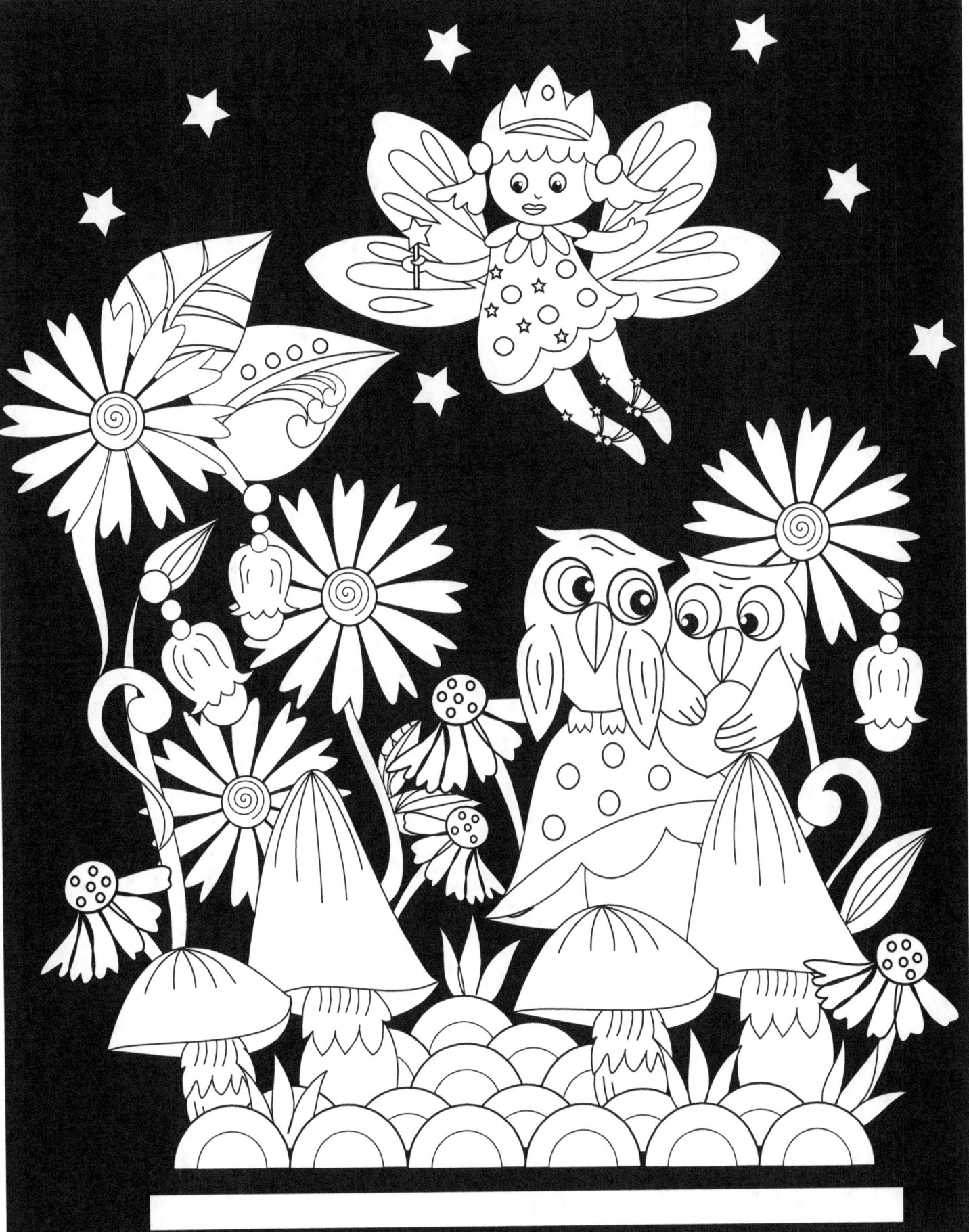

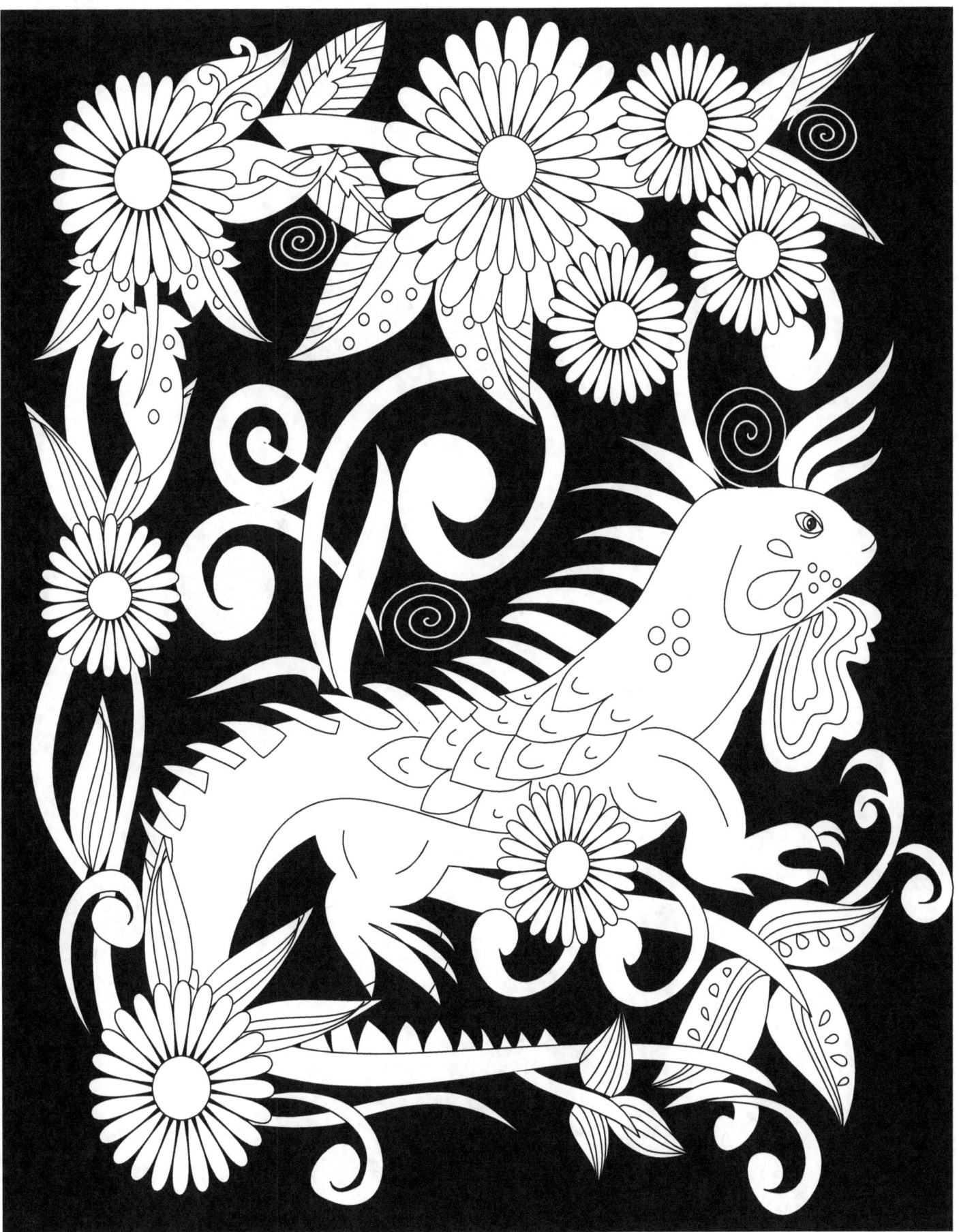

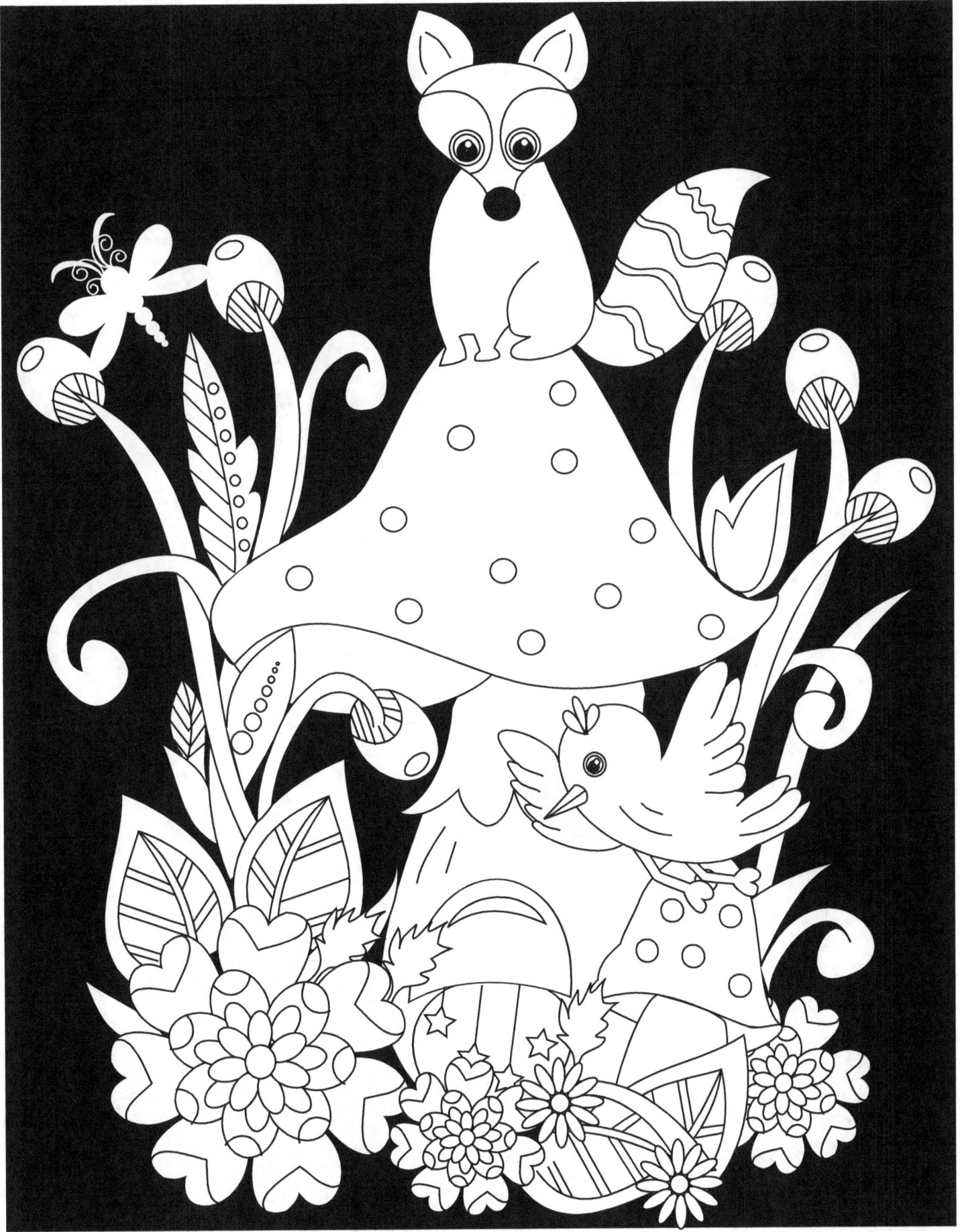

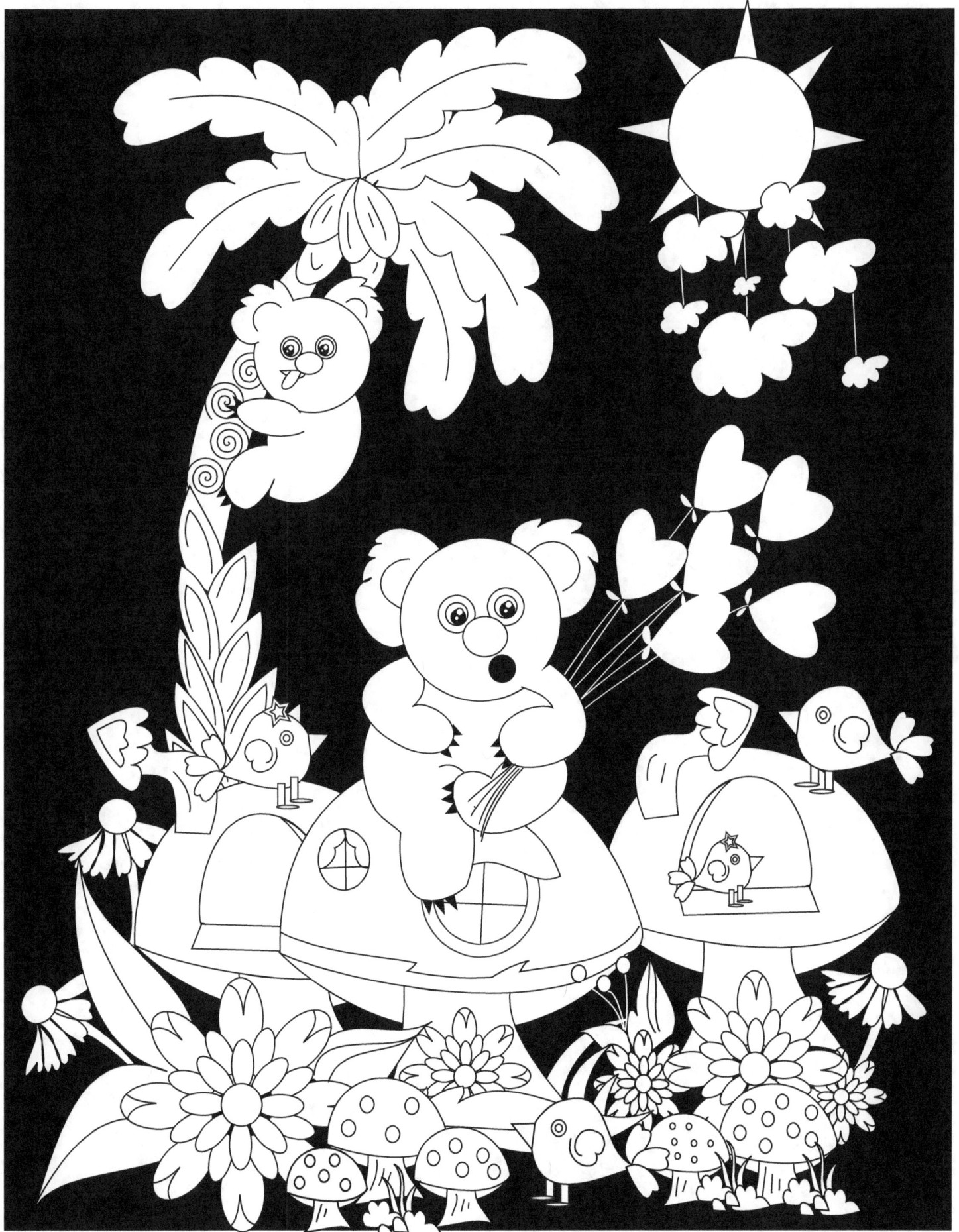

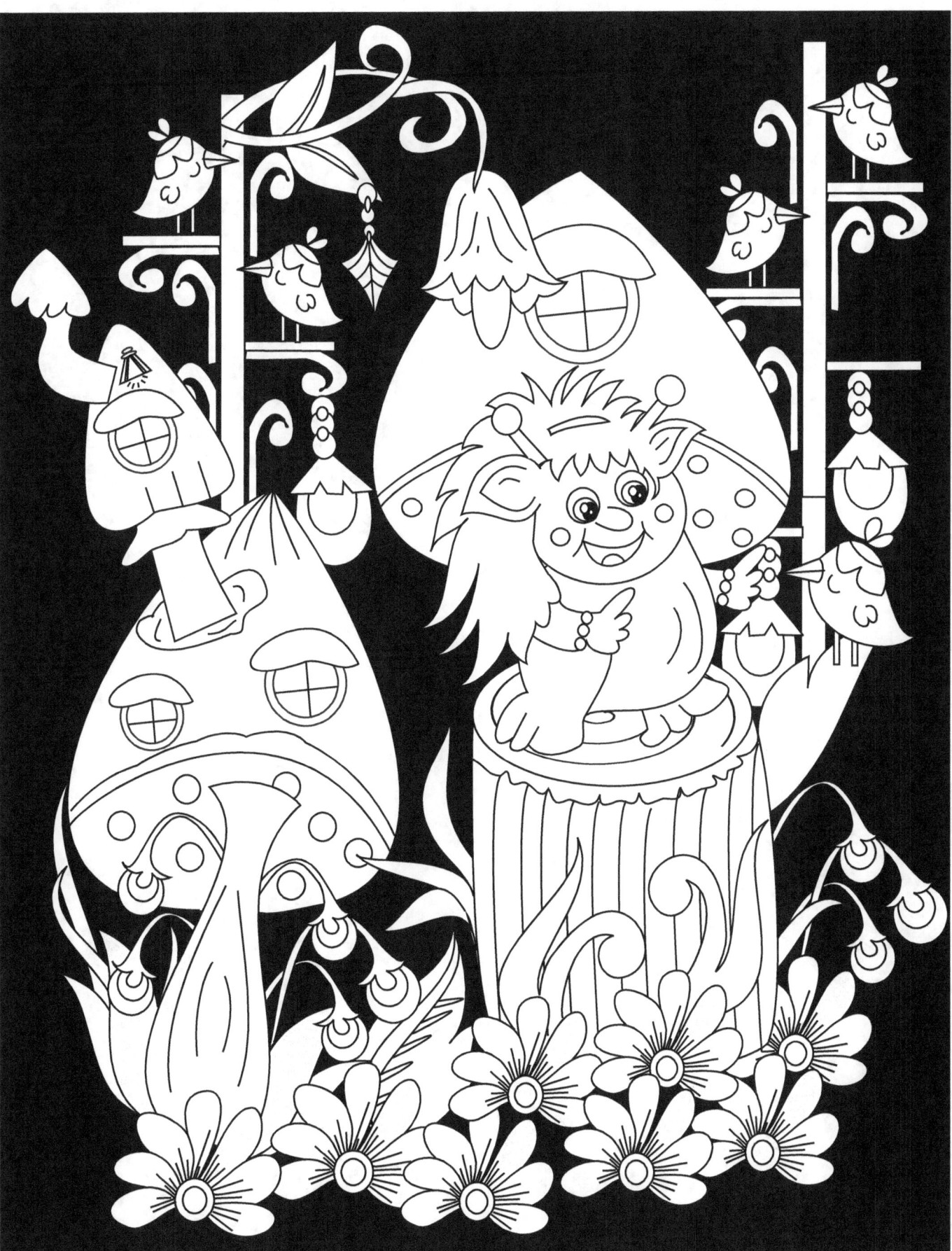

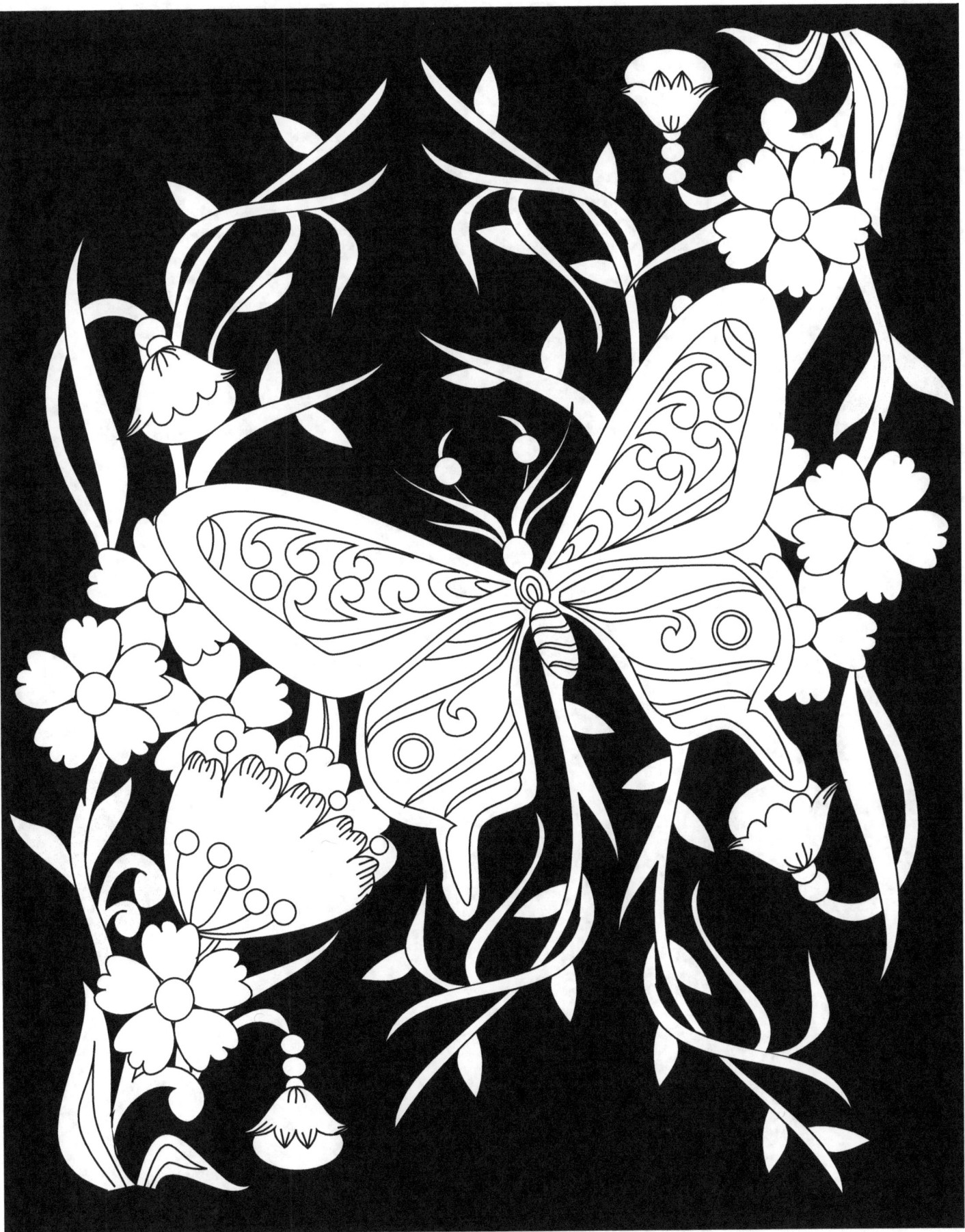

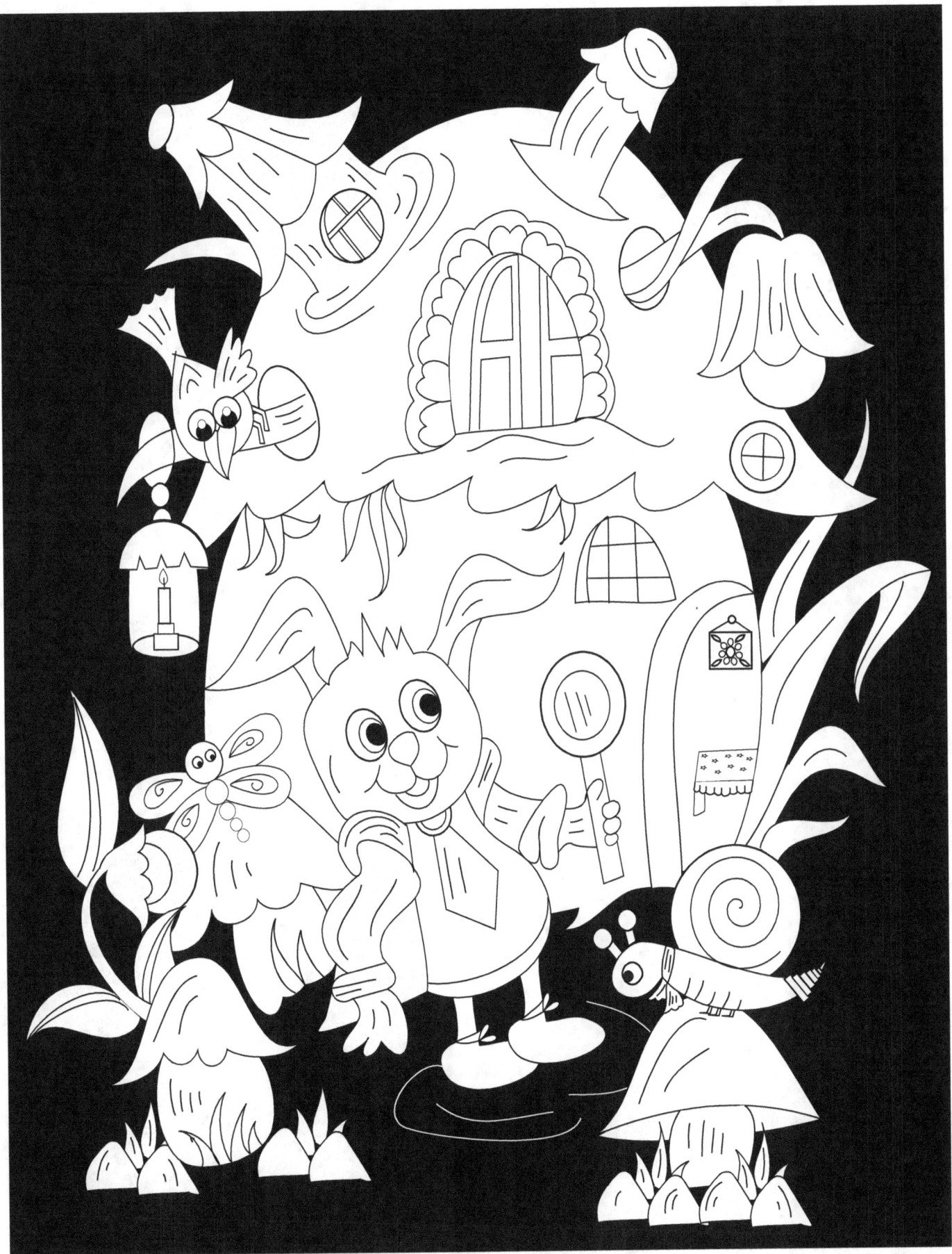